P9-CPV-186

PARADISE FOUND

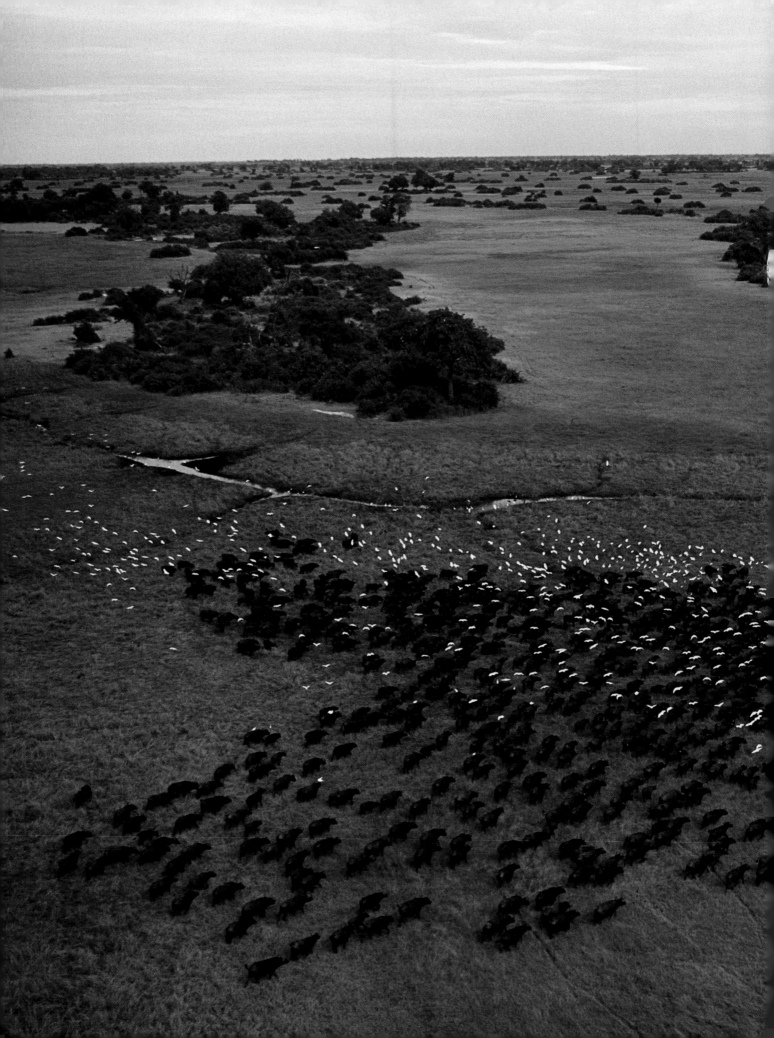

PARADISE FOUND

LIFE Books

Managing Editor Robert Sullivan
Director of Photography Barbara Baker Burrows
Deputy Picture Editor Christina Lieberman
Copy Editors Barbara Gogan, Parlan McGaw
Photo Associate Sarah Cates
Consulting Picture Editors
Mimi Murphy (Rome), Tala Skari (Paris)

Editorial Director Stephen Koepp

EDITORIAL OPERATIONS
Richard K. Prue (Director), Brian Fellows (Manager),
Richard Shaffer (Production), Keith Aurelio,
Charlotte Coco, Tracey Eure, Kevin Hart, Mert Kerimoglu,
Rosalie Khan, Patricia Koh, Marco Lau, Brian Mai,
Po Fung Ng, Rudi Papiri, Robert Pizarro, Barry Pribula,
Clara Renauro, Katy Saunders, Hia Tan, Vaune Trachtman

TIME HOME ENTERTAINMENT
Publisher Jim Childs
Vice President, Brand & Digital Strategy
Steven Sandonato
Executive Director, Marketing Services Carol Pittard
Executive Director, Retail & Special Sales Tom Mifsud
Executive Publishing Director Joy Butts
Director, Bookazine Development & Marketing Laura Adam
Finance Director Glenn Buonocore
Associate Publishing Director Megan Pearlman
Assistant General Counsel Helen Wan
Assistant Director, Special Sales Ilene Schreider
Senior Book Production Manager Susan Chodakiewicz
Design & Prepress Manager Anne-Michelle Gallero
Brand Manager Roshni Patel
Associate Prepress Manager Alex Voznesenskiy
Assistant Brand Manager Stephanie Braga

Special thanks: Katherine Barnet, Jeremy Biloon,
Rose Cirrincione, Jacqueline Fitzgerald, Christine
Font, Jenna Goldberg, Hillary Hirsch, David Kahn, Amy
Mangus, Kimberly Marshall, Amy Migliaccio, Nina Mistry,
Roshni Patel, Dave Rozzelle, Ricardo Santiago, Adriana
Tierno, Vanessa Wu

ISBN 10: 1-60320-124-6 • ISBN 13: 978-1-60320-124-7
Library of Congress Control Number: 2012954683

Produced in association with
KENSINGTON MEDIA GROUP
Editorial Director Morin Bishop
Designer Barbara Chilenskas
Copy Editor Lee Fjordbotten
Fact Checker Ward Calhoun

We welcome your comments and suggestions about
LIFE Books. Please write to us at:
LIFE Books
Attention: Book Editors
PO Box 11016
Des Moines, IA 50336-1016

If you would like to order any of our hardcover
Collector's Edition books, please call us at
1-800-327-6388. (Monday through Friday, 7:00 a.m.— 8:00
p.m. or Saturday, 7:00 a.m.— 6:00 p.m. Central Time).

Page 1: Pryor Mountain Wild Horse Range, Montana
Yva Momatiuk/John Eastcott/Minden
Pages 2-3: Okavango Delta, Botswana
Richard Du Toit/Minden/Corbis
These pages: Point Reyes, California
Conrad Piepenburg/Laif/Redux
Cover: Koh Phi Phi Lee, Thailand Jose Fuste Raga/Corbis
Back Cover: Neuschwanstein Castle, Germany Ray Juno/Corbis

CONTENTS

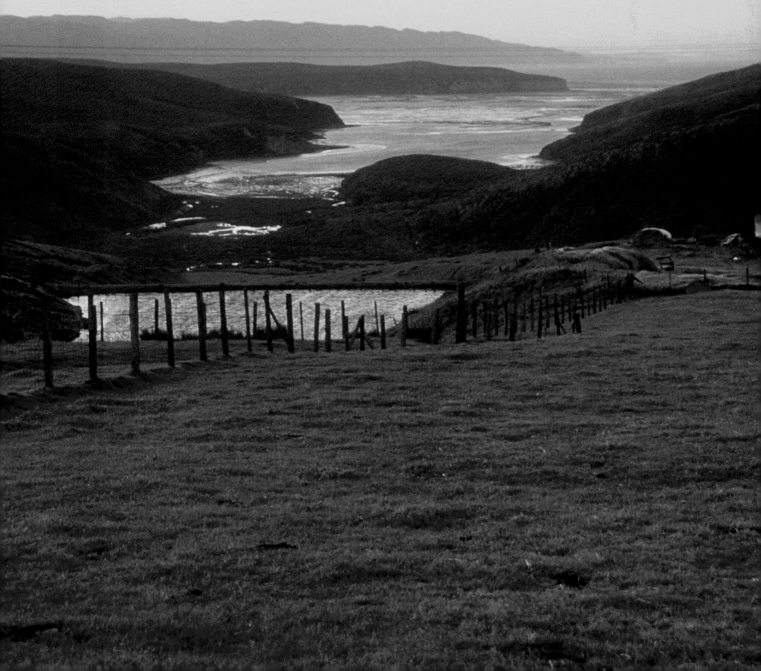

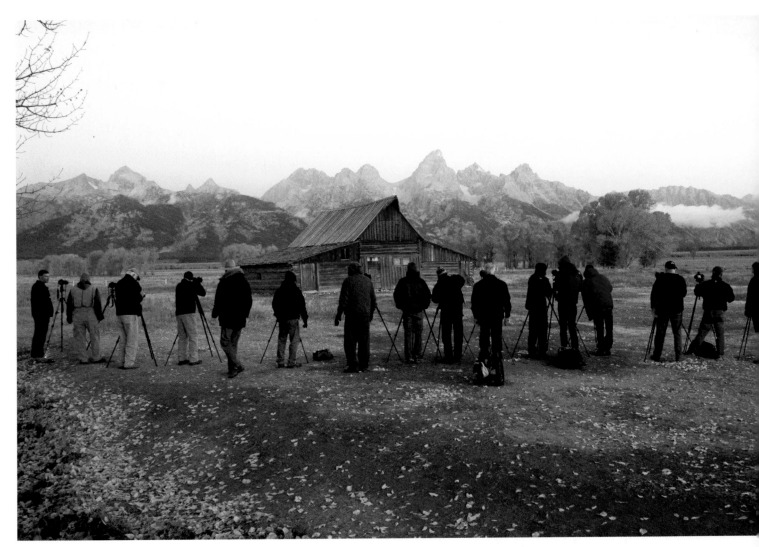

PHOTO OP *A gaggle of photographers gather to await the sunrise in Wyoming's Grand Teton National Park.*

Pleasures and Treasures off the Beaten Path

There is a strong fashion in popular books today that can be understood as: "Try this, not that." *Paradise Found* can be considered an entry in the Global Travel section.

Oh, certainly we feature sites and attractions that are well known, your Jackson Holes and St. Moritzes. But they are fewer and farther between than in some of our earlier books. As the title of this volume implies, we wanted to discover new places and share them with you. The world is a very big place, and in many, many parts it is astonishingly beautiful. We wanted, this time, to take the road less traveled, and surprise you with each turn of the page.

That said, right away we present a site familiar to any who have visited the Hawaiian island of Kauai, Waimea Canyon. Many of you, we realize, have not been fortunate enough to make that distant journey. You've gone on a family trip to the rim of Arizona's Grand Canyon, perhaps, but haven't visited Waimea or the Copper Canyon in Mexico or Antelope Canyon, also in Arizona, or the Gorges du Verdon in France. You may never go. But we want to show you these places nonetheless, since enjoying the sites as an armchair traveler is the next best thing to going. We have summoned the best nature

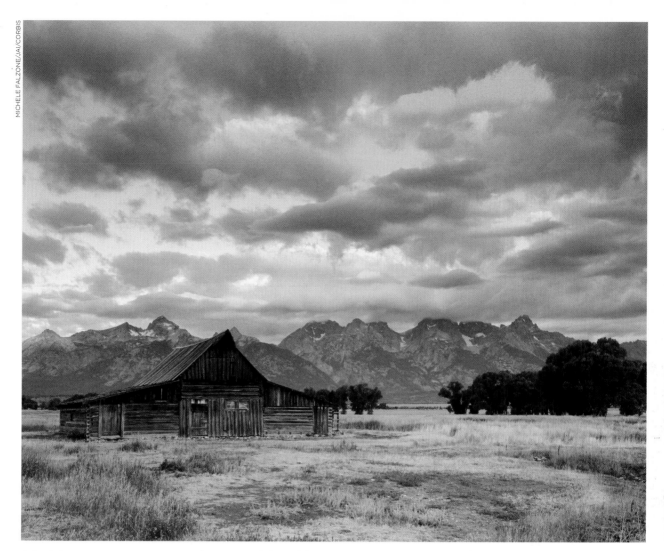

LANDSCAPE MASTERPIECE The wait and the cold are well worth it, as sunrise gilds the skies.

photography from many fine shooters known to us here at LIFE. This isn't a book of calendar art. The beauty reflected herein is really and truly out there, in both senses of the phrase.

We certainly hope that, too, we can inspire some of you to get out of that armchair, or to put some of these ideas in your back pocket for the next time you find yourself in this region or that one. You may never climb Mount Logan, even if you find yourself in the Yukon, but when you are next in the Midwest, plan a trip to Michigan's Sleeping Bear Dunes. You've been to Boston, but have you ever driven the half hour out to Concord to think things over on the shores of Thoreau's Walden? Next time you're

playing golf in Ireland, take an afternoon off for a side trip to Skellig Michael. Australia isn't all about Adams Rock and the Great Barrier Reef. When you head out on that once-in-a-lifetime trip Down Under, make a longer list. And then again, if small Iceland offers as much as we claim—and it does—maybe Iceland needs to be the next vacation.

So this book works in many ways, but our overarching goal is that it serve as a source of surprises, constant and beautiful surprises. And whether you are in your armchair or gazing into the canyon itself, there's a final crucial advantage to seeking out secret little bits of paradise: You'll have them all to yourself.

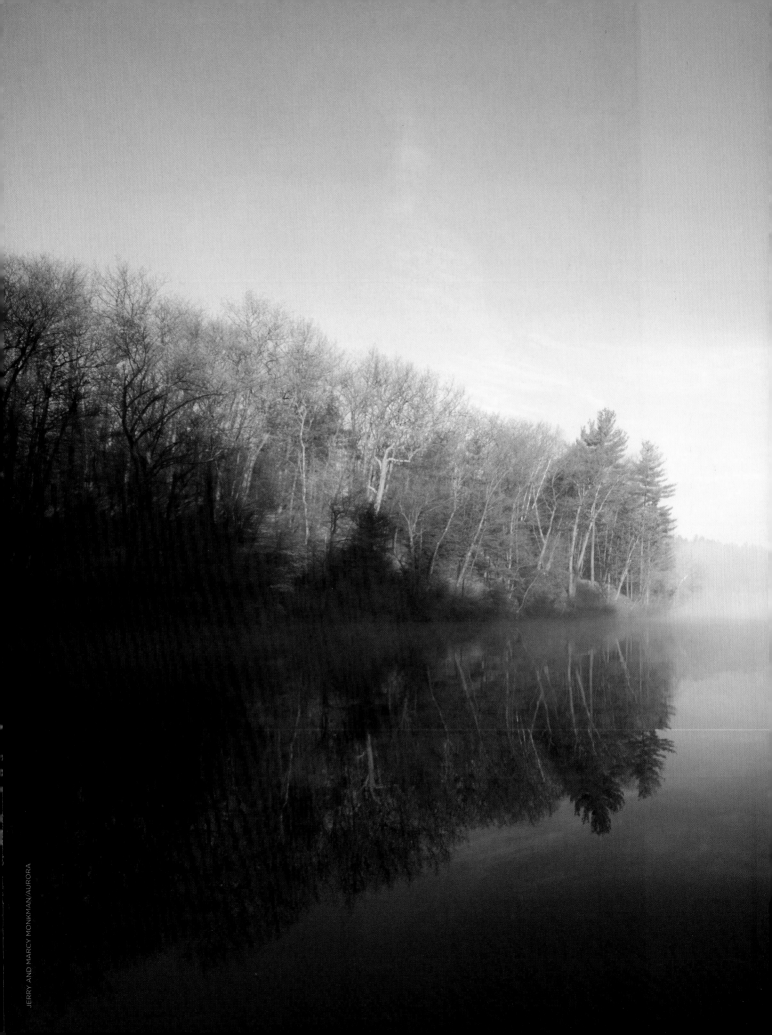

AMERICA

WALDEN POND enticed Thoreau to its leafy environs in 1845. (Please see page 21.)

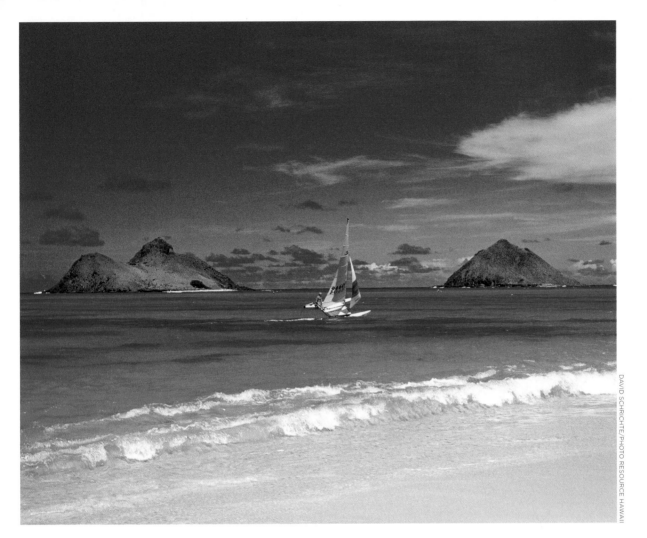

LANIKAI BEACH
Oahu, Hawaii

Located on the windward, southeast, side of Oahu, this tiny half-mile beach draws locals, tourists and photographers to its turquoise waters, fine white sand and stunning views of the two islands that serve as bird sanctuaries just offshore. *Lanikai* means "heavenly sea" in the Hawaiian language, and with a reef near shore to keep the water warm and the waves child-friendly, it is easy to see why. Erosion has cut the length of the beach in half in recent years, so those considering a visit should plan one soon.

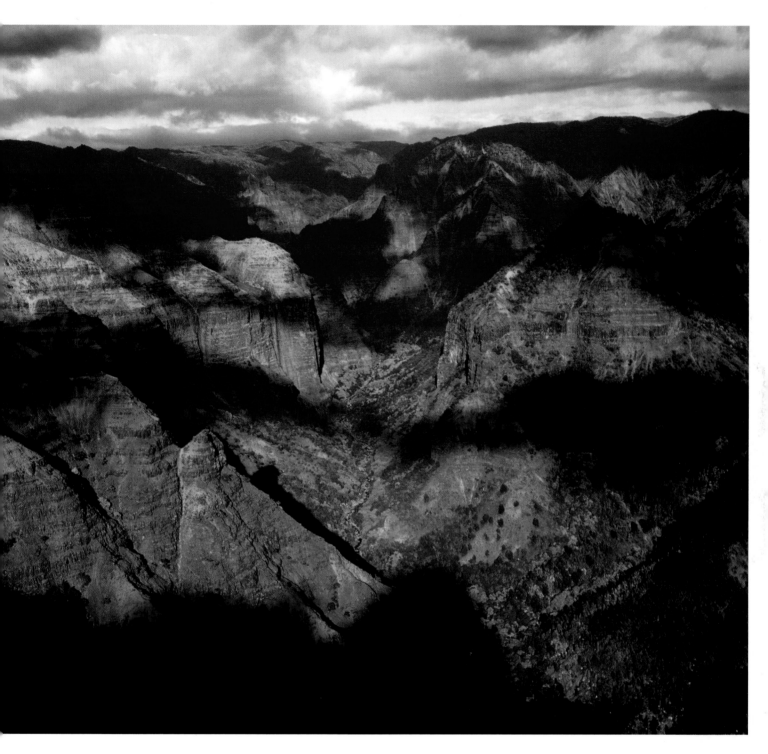

WAIMEA CANYON
Kauai, Hawaii

Given its astonishing size at 14 miles long, one mile wide and 3,600 feet deep, it is not surprising that this geological wonder is known as "the Grand Canyon of the Pacific." Formed by an unusual combination of erosion (a result of the extremely high rainfall levels on Mount Wai'ale'ale that feed into the Waimea River) and the catastrophic collapse 4 million years ago of the volcano that created Kauai, the canyon has become popular with tourists drawn by its miles of hiking trails as well as its eye-catching views of the island of Nihau, just west of Kauai.

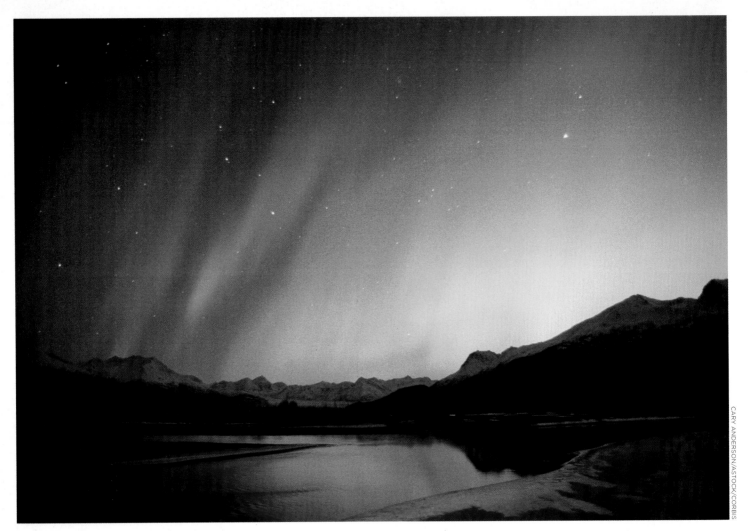

GIRDWOOD
Alaska

Girdwood is best known as the site of the popular Alyeska ski resort, nestled in a valley of the Chugach Mountains near Anchorage at the eastern end of the Turnagain Arm of Cook Inlet. But from late August to early April, the extraordinary skiing competes for pride of place with the magical northern lights, a.k.a. aurora borealis, an astonishing visual display produced by the collision of charged particles and atoms in the upper atmosphere and viewable only in latitudes near the Arctic Circle. The result, as with this example above the Knik River some 60 miles north of Girdwood, is a dazzling array of colors that seem to dance before the enchanted viewer's eyes.

GIFFORD PINCHOT NATIONAL FOREST
Washington State

An intrepid visitor rappels down the main Summit Creek waterfall in Gifford Pinchot National Forest, one of the nation's oldest. Originally designated the Columbia National Forest in 1908, it was renamed in 1949 in honor of Pinchot, the first chief of the U.S. Forest Service and a leading conservationist. The forest now covers 1,312,000 acres and includes the 110,000-acre Mount St. Helen's National Volcanic Monument. Whether camping, hiking, hunting, fishing or simply enjoying the breathtaking views of lakes, waterfalls, mountain peaks and even lava beds, delights abound around every bend of the trail at Gifford Pinchot.

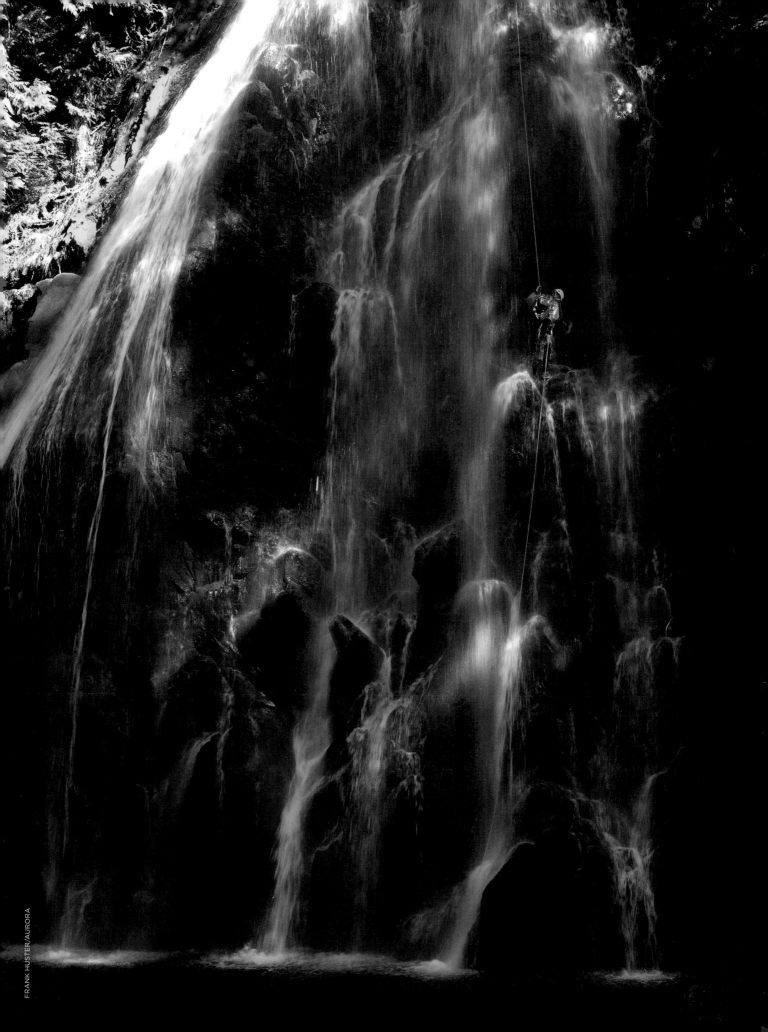

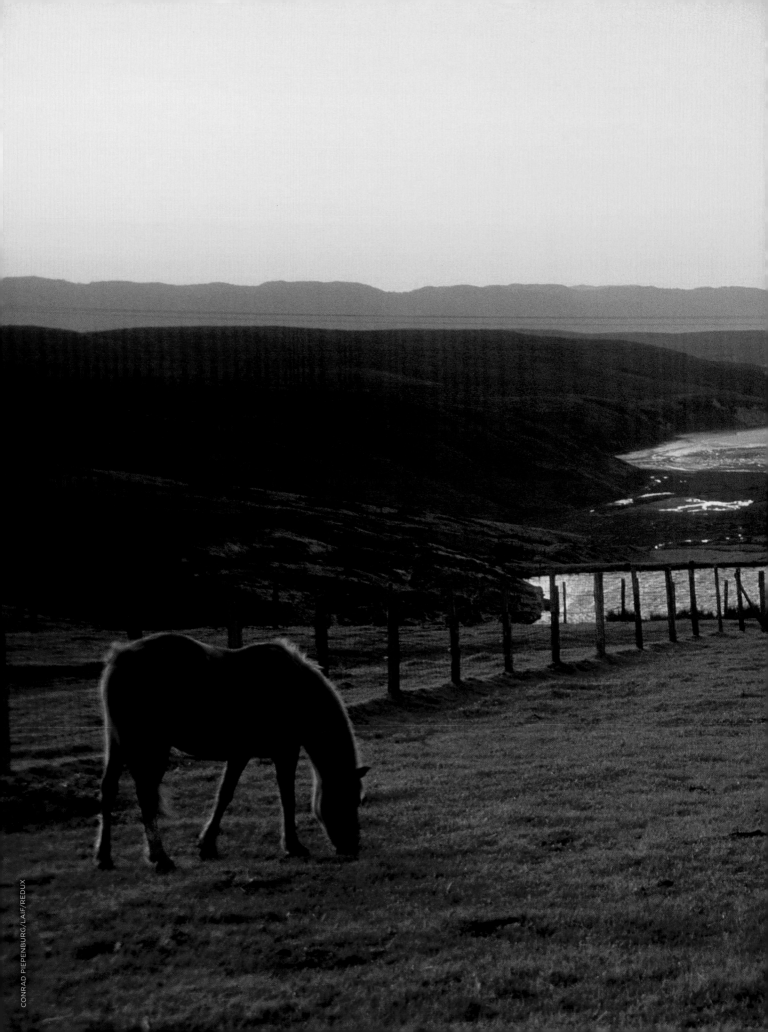

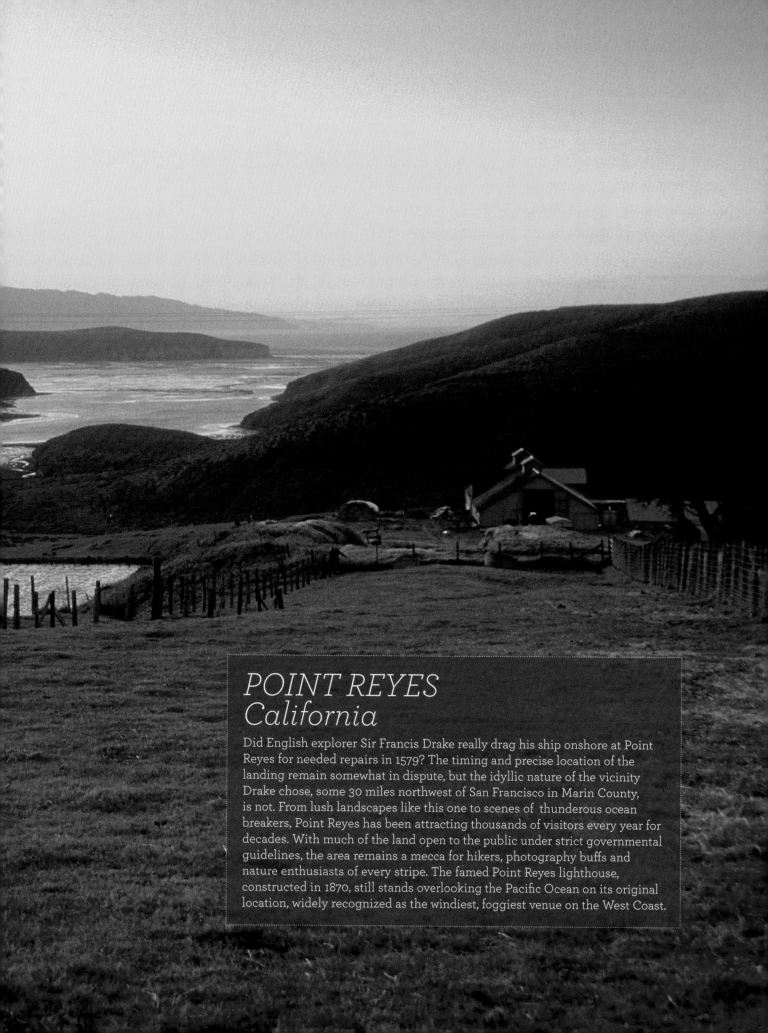

POINT REYES
California

Did English explorer Sir Francis Drake really drag his ship onshore at Point Reyes for needed repairs in 1579? The timing and precise location of the landing remain somewhat in dispute, but the idyllic nature of the vicinity Drake chose, some 30 miles northwest of San Francisco in Marin County, is not. From lush landscapes like this one to scenes of thunderous ocean breakers, Point Reyes has been attracting thousands of visitors every year for decades. With much of the land open to the public under strict governmental guidelines, the area remains a mecca for hikers, photography buffs and nature enthusiasts of every stripe. The famed Point Reyes lighthouse, constructed in 1870, still stands overlooking the Pacific Ocean on its original location, widely recognized as the windiest, foggiest venue on the West Coast.

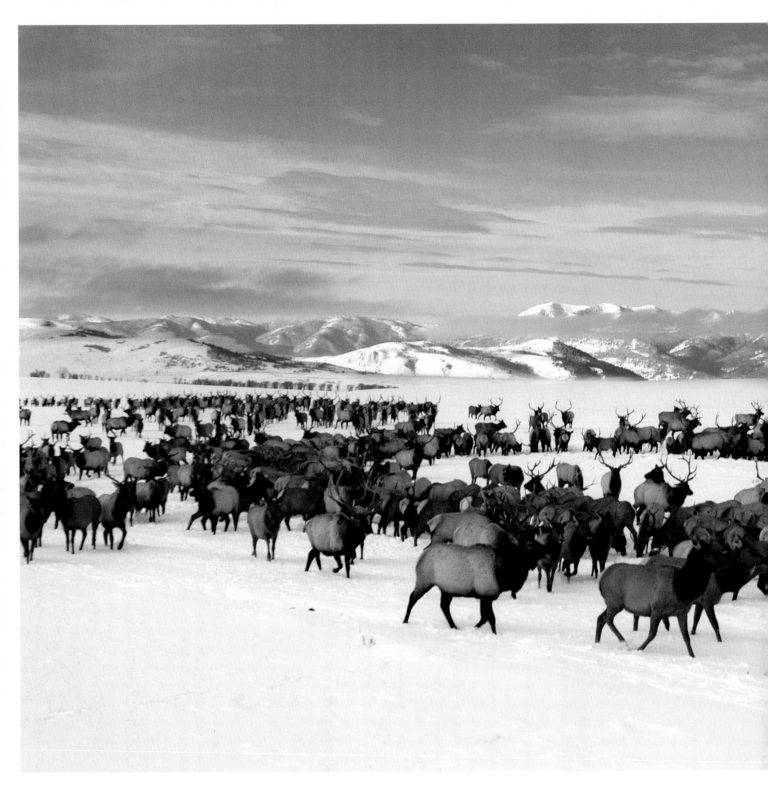

JACKSON HOLE
Wyoming

It's really more of a valley, but the term *hole* seems apt as well when one considers the steep mountains that rise on all sides around this Wyoming locale. The Tetons tower up to 7,000 feet over the valley in the west, and to the east the Gros Ventre Mountains also provide dramatic views. Roaming freely throughout the valley in the winter are herds of elk like those above, hardy creatures able to withstand the oftentimes bone-chilling temperatures. Outstanding skiing is available year-round at the Jackson Hole Mountain Resort, Snow King and Grand Targhee Resort, while those seeking a respite from the slopes can hop in the car for a quick side trip to the nearby Grand Teton and Yellowstone National Parks.

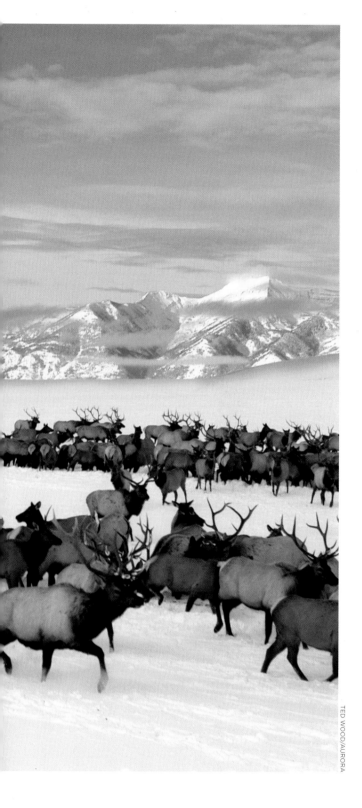

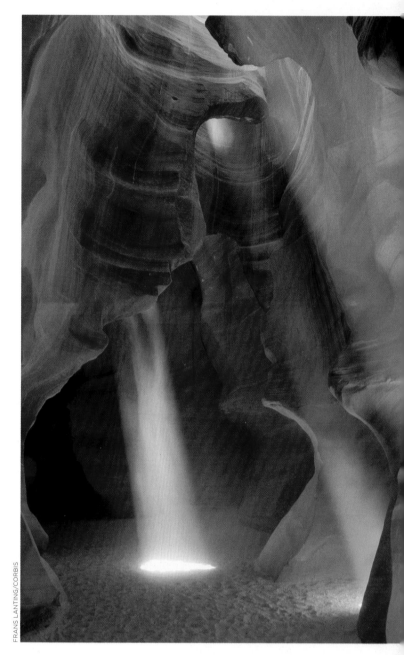

ANTELOPE CANYON
Arizona

One of nature's most awe-inspiring cathedrals, this so-called "slot" canyon on Navajo land in northern Arizona has been open to the public since 1997, when the Navajo Nation designated it as a Navajo Tribal Park. Since then, Antelope Canyon has become among the southwest's most popular destinations, luring photographers and casual visitors alike with its stunning array of surreal shapes and colors, formed from its malleable sandstone walls. Named for the pronghorn antelope that once populated the area in vast numbers, the canyon was formed over thousands of years, the result of high rains and flash flooding that shaped the walls into their hallmark flowing shapes.

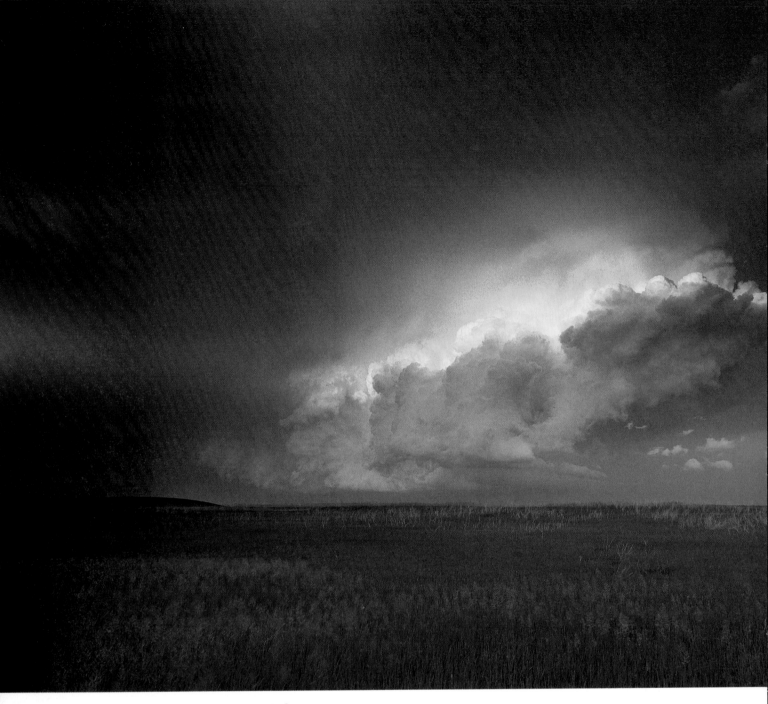

THE GREAT PLAINS

Stretching from the Rocky Mountains in the west to the Mississippi River in the east, and from Canada in the north to Mexico in the south, the Great Plains encompass an enormous swath of land, but for many Americans this stunningly diverse, agriculturally rich and still in many cases surprisingly untamed part of their country remains largely unexplored, a crazy quilt of patchwork color to gaze down upon as one flies across the nation en route to one coast or the other. But to neglect this region is to miss one of America's most beautiful natural habitats, with stunning vistas like the sun setting fire to a storm cloud over the prairies in Badlands National Park in South Dakota. Here, one can imagine the land as the fiercely independent Plains Indians might have seen it: pristine, unspoiled, still subject to nature's harsh rhythms.

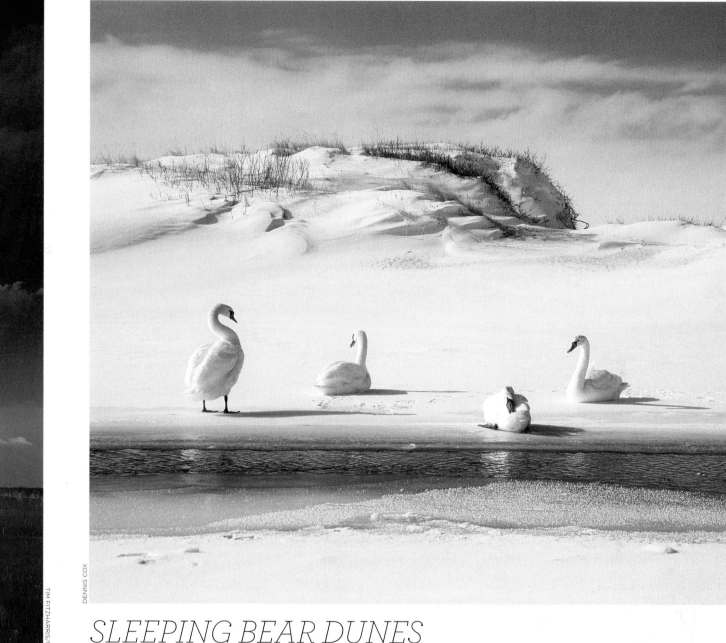

SLEEPING BEAR DUNES
Lake Michigan

The glories of the Grand Canyon, the quaintness of Vermont, the grandeur of Yosemite—all have captured the imaginations of Americans for decades. But of all the natural wonders within the 50 states, which is the most beautiful? According to a national poll conducted by *Good Morning America* in 2011, that title belongs to Sleeping Bear Dunes, a stunning 35-mile stretch of beachfront along the eastern shore of Lake Michigan in northwest Michigan. The name derives from an ancient Chippewa legend about a mother bear and her two cubs, who attempted to swim across Lake Michigan to escape a raging fire on its western shore. The mother bear made the journey successfully, but her two cubs drowned. The spot where the cubs drowned—six miles off the eastern coast—was covered with sand by the great god Manitou to form North and South Manitou Islands, while the mother bear, now buried beneath centuries of sand, continues to wait on the eastern shore, the "sleeping bear" mourning her lost offspring. Stay in one of the area resorts, fish the waters, grab a canoe or just bask on the amazing beaches—Sleeping Bear Dunes is truly an American gem.

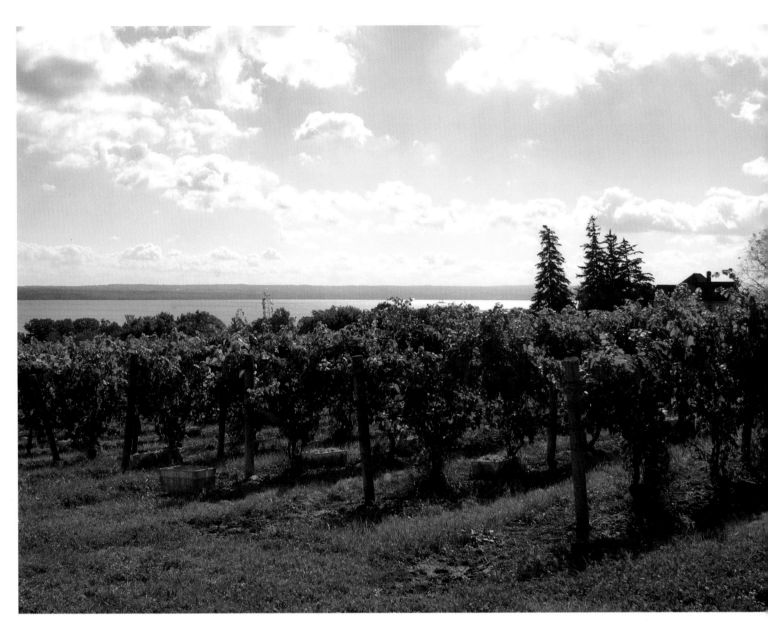

FINGER LAKES
New York

These 11 narrow lakes in upper New York State really do resemble fingers, and they have been beckoning visitors to their lovely unspoiled shores for more than a century. The two largest lakes, Cayuga and Seneca (both nearly 40 miles long), are also unusually deep, with Seneca the deeper of the two, its bottom more than 600 feet below the surface and well below sea level. Excellent fishing—the local trout is delicious—numerous hiking, skiing and snowmobile trails, an array of terrific inns, and boating of every variety provide the area with exceptionally wide appeal. For something a little different, consider a tour of Canandaigua Lake on a double-decked paddlewheel boat or a visit to one of the more than 100 wonderful wineries in the area (the Finger Lakes produce more wine than any other region in the state).

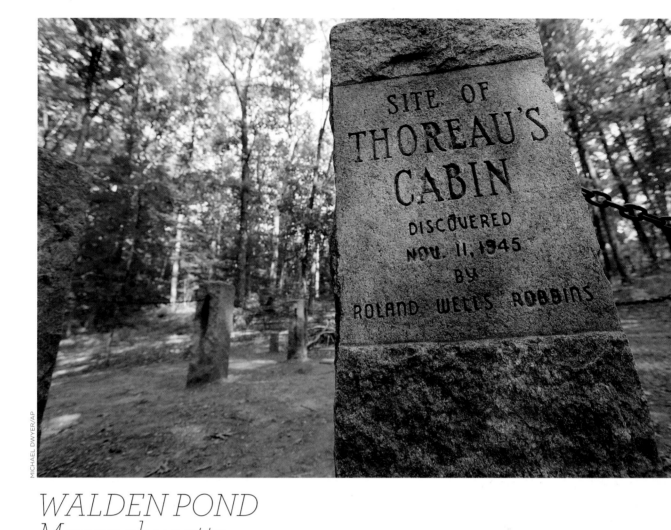

WALDEN POND
Massachusetts

Who has not imagined, when overwhelmed with the complexity and pressure of contemporary life, what it might be like to do as Henry David Thoreau did and simply drop out, decamp to the wilderness and see just what benefits might accrue from a simpler existence? Thoreau himself found it most restorative, of course, as well as productive—*Walden*, the wonderful book based on his experience, has been read by millions since its publication some 160 years ago and is considered by many as the beginning of the environmental movement, which still looks to it for inspiration. By comparison with the extensive Finger Lakes, which are arrayed in a swath of territory some 100 miles wide, Walden is tiny, just 1.7 miles in circumference, but visitors to the pond might still find just enough solitude to ponder Thoreau's profound mission: "I went to the woods because I wished to live deliberately, to front only the essential facts of life, and see if I could not learn what it had to teach, and not, when I came to die, discover that I had not lived."

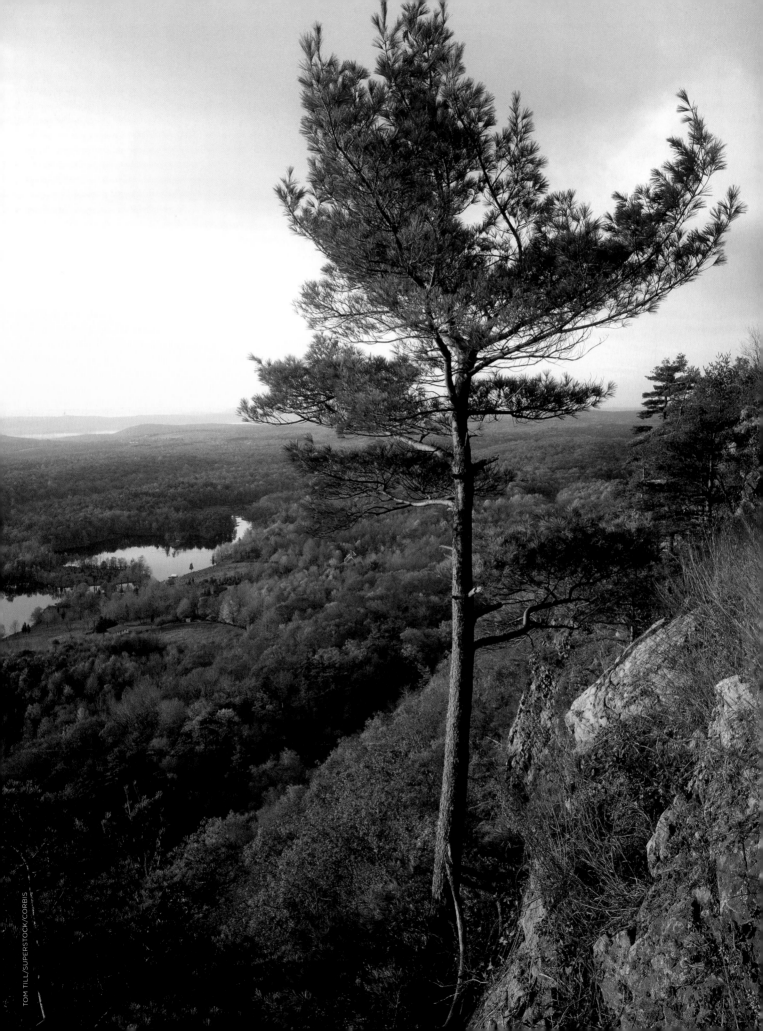

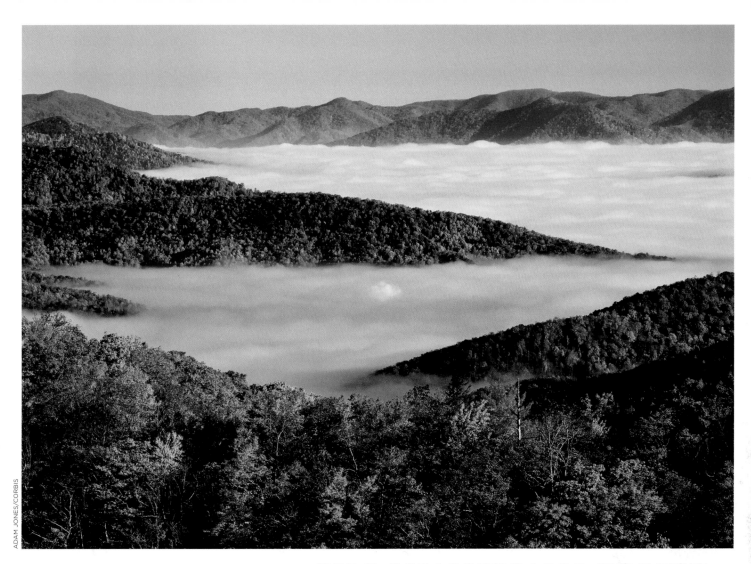

DELAWARE WATER GAP
Pennsylvania

At 70,000 acres and running along the middle section of the Delaware River from the Delaware Water Gap northward into New Jersey and Pennsylvania on the eastern and western sides of the river, respectively, the Delaware Water Gap National Recreation Area is not as large or as mountainous as Pisgah, but it remains a naturalist's paradise nonetheless. Inhabited by humans for some 10,000 years and drawing vacationers since the Victorian era, the mighty Delaware defines many of the most rewarding activities, including opportunities to hike, paddle canoes, wade into trout streams or simply enjoy the many lovely views like this one, with the river in the far distance across the verdant Kittatinny Valley.

PISGAH NATIONAL FOREST
North Carolina

This enormous forest in the Appalachian Mountains in western North Carolina, replete with mile-high peaks, cascading waterfalls and a multitude of trails through lushly wooded slopes that burst into glorious color in the fall, is surely among the nation's most sensational natural areas. All the expected activities associated with such a wooded wonderland pertain: hiking, camping, climbing, fishing, hunting, swimming, tubing, and on and on. And if, at the end of your sojourn in the mountains, you find yourself in need of more extensive human contact, drop down to Asheville, perhaps the most cosmopolitan, culturally rich community of 89,000 to be found anywhere.

CHATTAHOOCHEE
Georgia

A path beckons through a maze of fog-enshrouded oak trees in Chattahoochee National Forest in northern Georgia. Should you accept the invitation? Chattahochee has over 450 miles of hiking trails—some geared to a brief half-day sojourn, others to much lengthier treks—so the choice is not easy. Perhaps a challenging climb to windswept Brasstown Bald, the highest summit in Georgia, is just the thing to whet your mountaineering appetite. Or maybe you'd prefer a trail near Anna Ruby Falls, where the sound of roaring waters is ever in your ears, reaching fever pitch when you reach the double cascade falls, with their dramatic 203-foot drop. Whatever you choose, the Chattahoochee River will never be far.

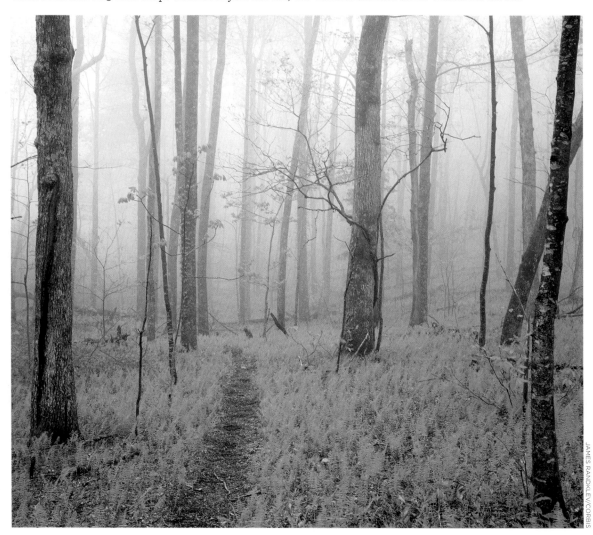

JAMES RANDKLEV/CORBIS

SANIBEL, *Florida*

Sanibel and Captiva Islands are Florida at its least Floridian. Forget the strip malls, chain restaurants and industrial architecture that dominate so much of the rest of the state and get ready for the much funkier, almost Caribbean vibe that typifies these two barrier islands off the southwest coast in the Gulf of Mexico. Intimate local restaurants, shabby-chic little inns, glorious white sand beaches and shells, shells, shells abound. What you won't find on Sanibel and Captiva are stop lights, buildings higher than the tallest palm tree, or any kind of development not in keeping with the low-key sensibility.

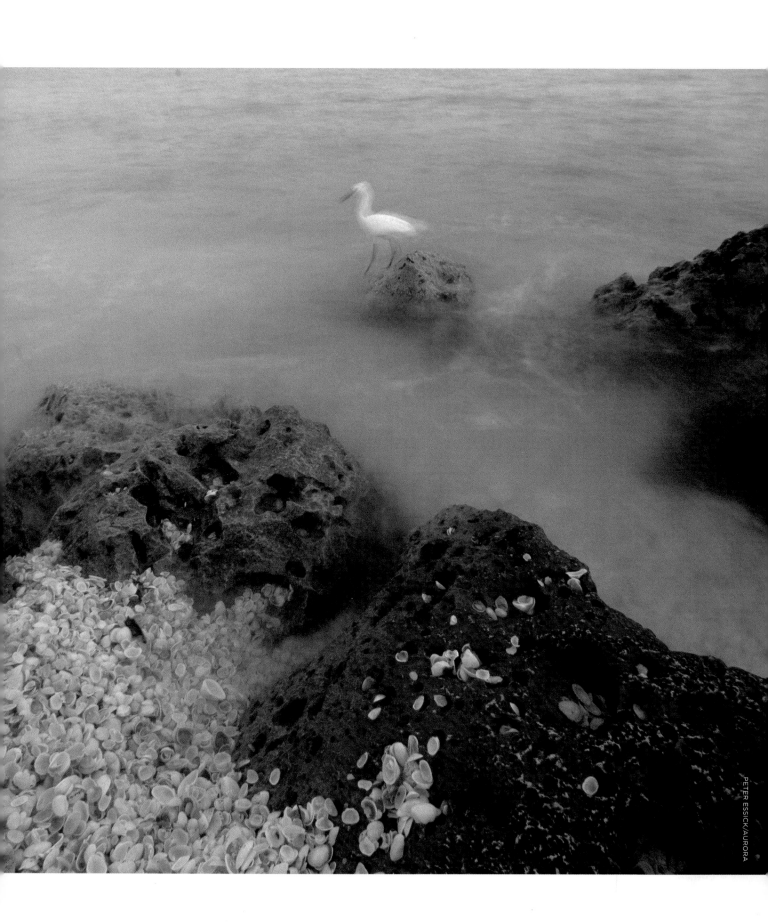

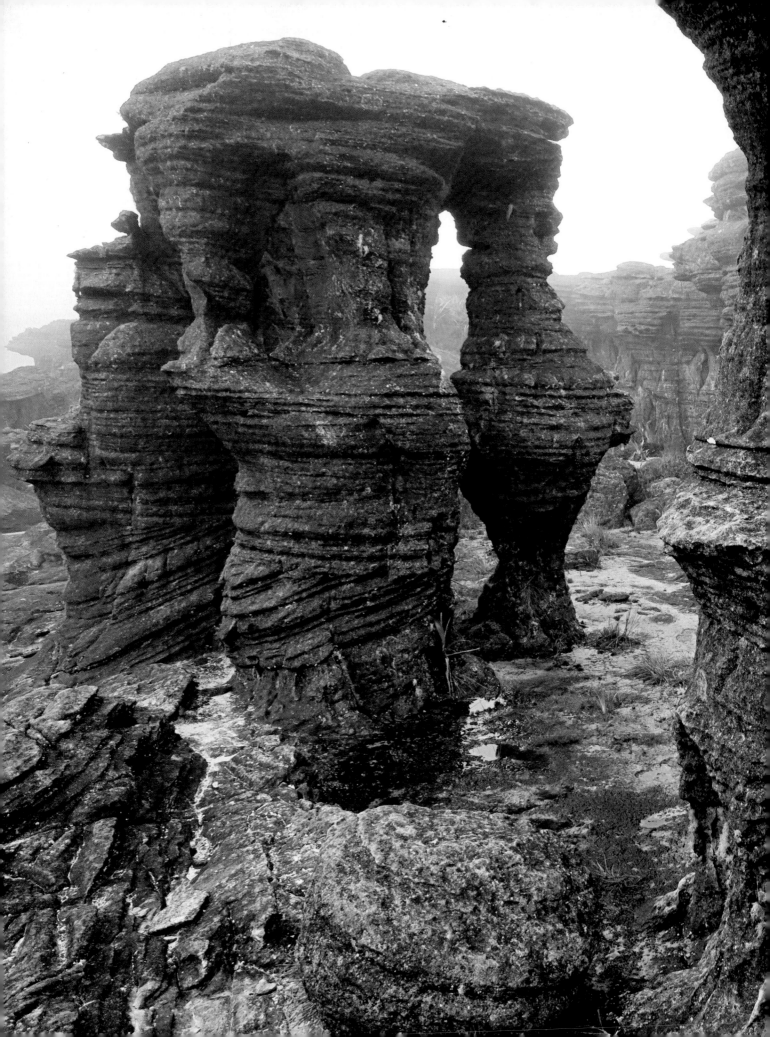

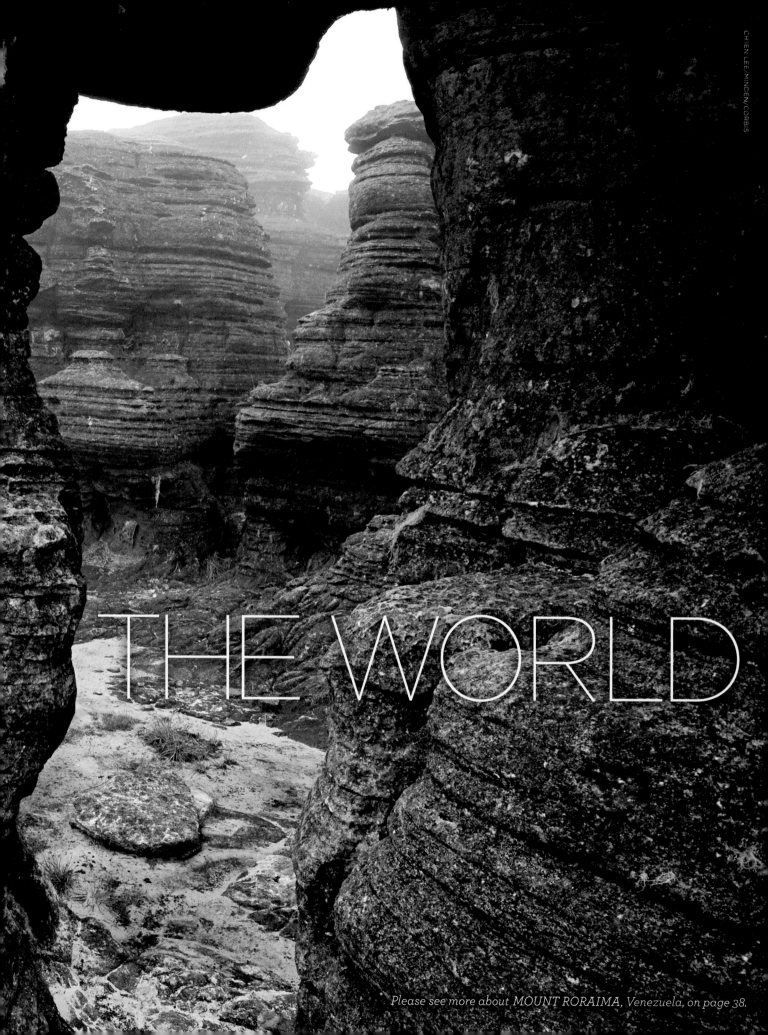

THE WORLD

Please see more about MOUNT RORAIMA, Venezuela, on page 38.

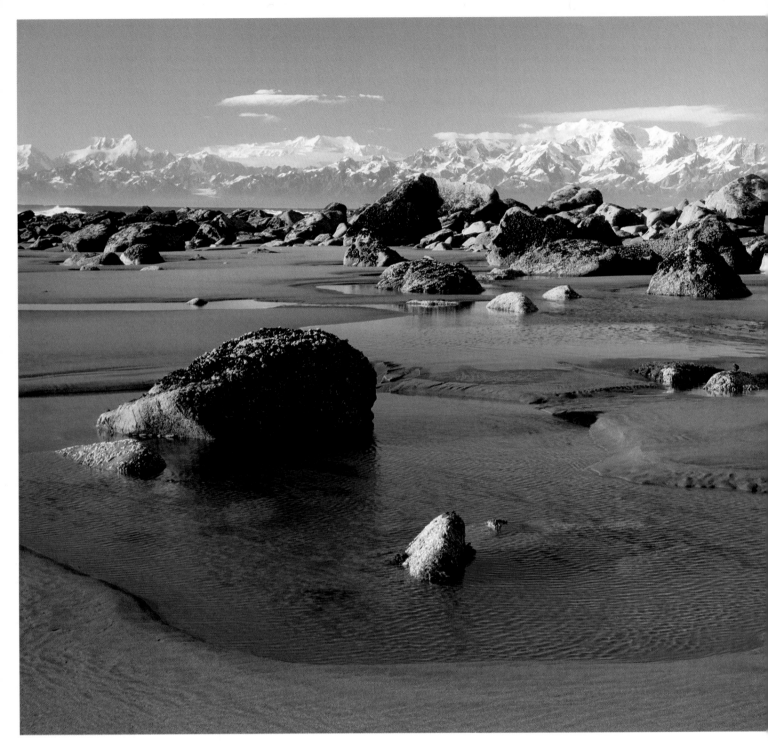

MOUNT LOGAN
Yukon, Canada

Even from a vantage point some 50 miles away on the Alaskan coast, the imposing peak of Mount Logan dominates the landscape. With an elevation of 19,551 feet, it is the loftiest mountain in Canada and is second only to Mount McKinley (20,320 feet) in all of North America. Conditions on the mountain are extremely inhospitable, with a median temperature of –17 degrees on the plateau at 16,404 feet, a stunning number that typically dips to –49 degrees in the winter months. Nonetheless, the summit has been reached a handful of times since the first successful ascent in 1925. Two noted climbers were killed during a failed attempt in 1987, and three more had to be rescued and treated for frostbite in 2005.

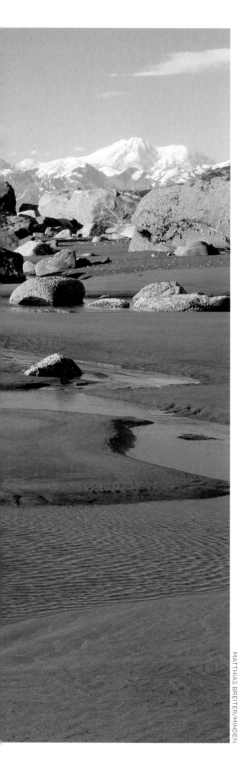

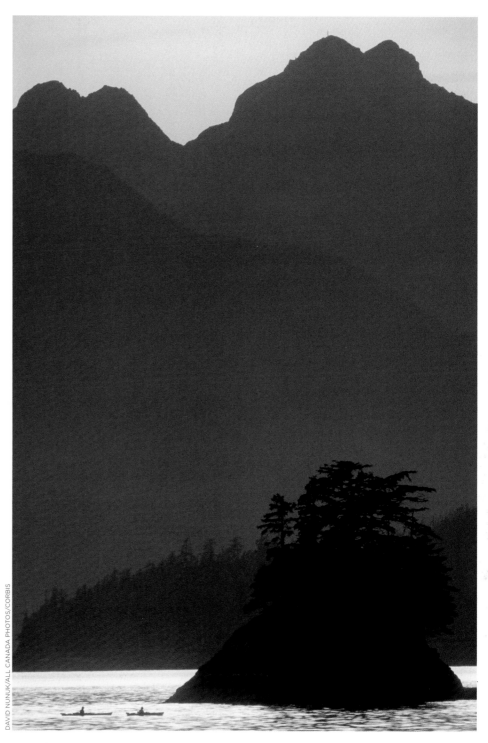

GWAII HAANAS NATIONAL PARK
British Columbia, Canada

Located on Native American land 81 miles off the coast of British Columbia, Gwaii Haanas National Park is jointly managed by the Haida Nation and the Canadian government. The name means "islands of beauty" in the Haida language and the park lives up to its name with a distinctive necklace of 138 islands. Endowed with stunningly diverse landscapes—from deep fjords to sub-alpine tundra, from salmon spawning streams to rugged mountains, from a collection of 40 freshwater lakes to acres and acres of deep forest—the park offers a wide array of terrain to explore. Seabirds—auklets, murrelets, puffins—abound, along with distinctive native species of black bear, Sitka black-tailed deer, raccoons, squirrels and beaver. Fishing, kayaking and camping are just three of the many activities that await.

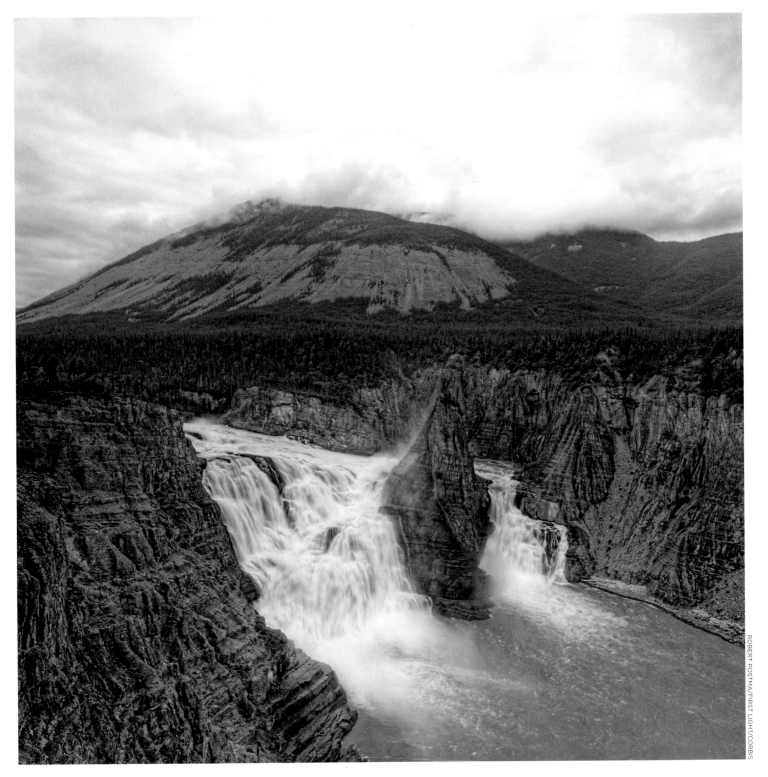

VIRGINIA FALLS
Northwest Territories, Canada

If your lifelong wish has to been to truly get away from it all, a canoe trip down the wild Nahanni River (part of the Nahanni National Park Reserve) in the remote Northwest Territories of Canada, 100 miles from the nearest town, is just the thing. Requiring up to five separate flights to get there from the eastern U.S.—the last one aboard a tiny so-called float plane—the river will take you through dramatic canyons, across crystal clear lakes, and past miles of genuinely virgin forest. At Virginia Falls, the roaring river plunges 295 feet—some 120 feet more than the height of Niagara Falls—producing soaring plumes of spray. In the middle of the falls, stubbornly resisting all efforts to knock it down, is Mason's Rock, named for noted Canadian canoeist and author Bill Mason.

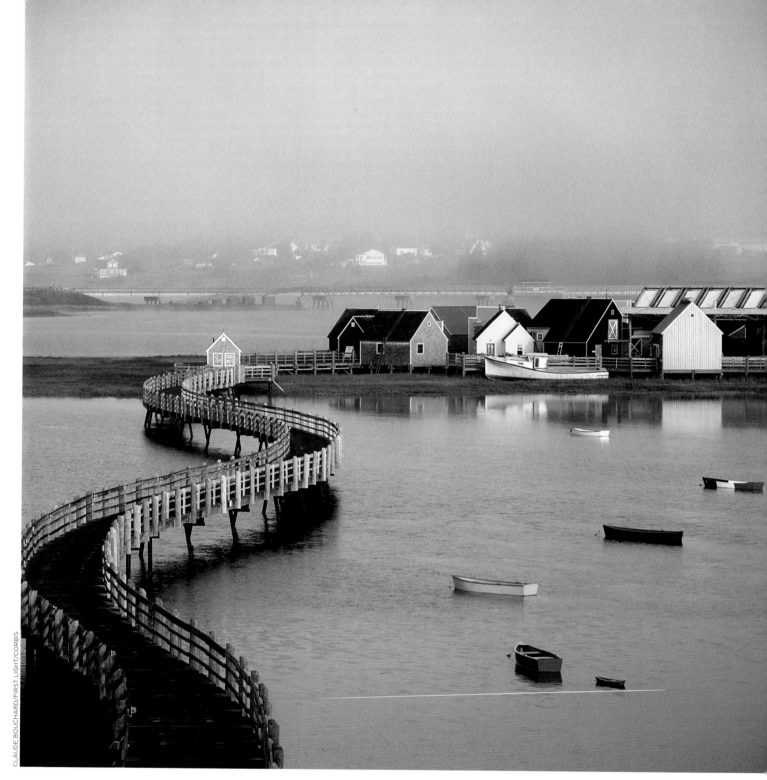

LE PAYS DE LA SAGOUINE
New Brunswick, Canada

Had enough of theme-park vacations? If so, pack up the family and head to New Brunswick, just north of Moncton to be precise, where Le Pays de la Sagouine offers a fresh look at an unfamiliar subject to most Americans: the vibrant history of Acadian culture. Based on the plays and novels of Antonine Maillet (b. 1929), this recreated Acadian village offers theater, music, food and drink, all presented by actors in authentic Acadian garb, speaking the unique inflections of Acadian French and celebrating all things Acadian. La Sagouine, a witty and wise Acadian cleaning lady from rural New Brunswick, is one of Maillet's most enduring characters.

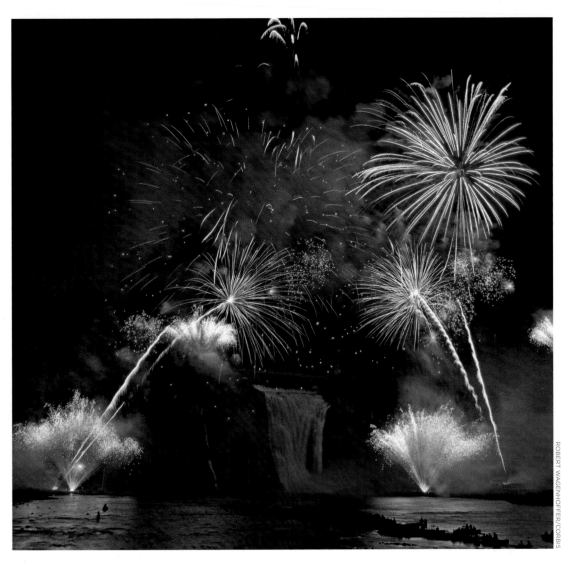

MONTMORENCY FALLS
Quebec, Canada

Montmorency Falls, 275 feet high and 150 feet wide, and only seven miles outside Quebec City, are sensational at any time of the year, with strategically placed stairways allowing visitors to view the falls from a variety of vantage points. A suspension bridge across the crest of the falls offers heart-stopping views of the crashing waters, and an aerial tram takes visitors on a stirring ride from the base to the top of the falls. But the falls take on an even more dramatic aspect every summer when an international fireworks competition lights up the skies above and waters below with splashes of vibrant color.

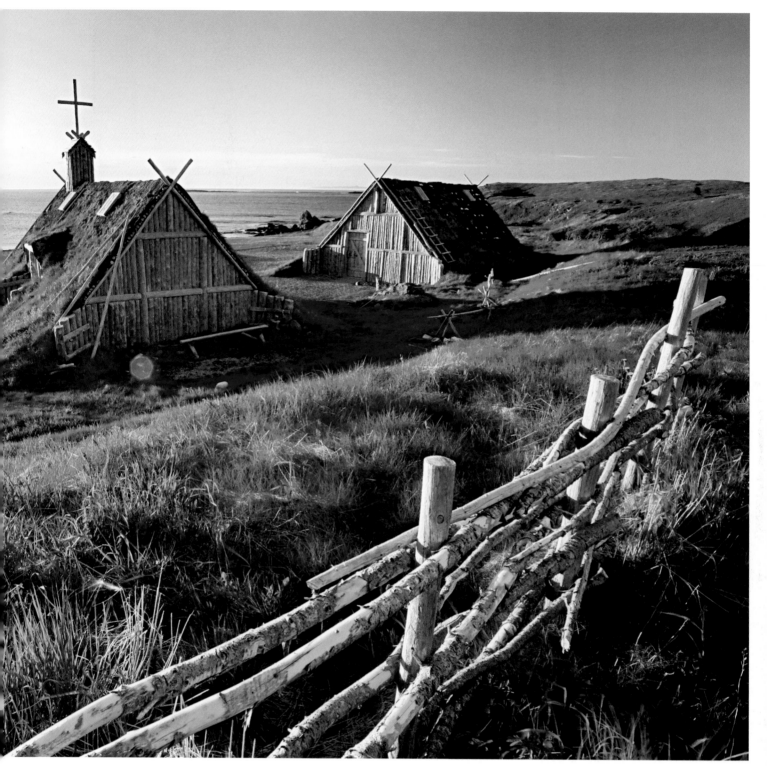

L'ANSE AUX MEADOWS
Newfoundland, Canada

In 1960, Norwegian writer and explorer Helge Ingstad unearthed the earliest known European settlement in the New World at L'Anse aux Meadows, on the northern tip of Newfoundland. Now a National Historic Site, L'Anse aux Meadows offers visitors a peek into the lifestyles and habits of the Vikings who lived there some one thousand years ago through guided tours of the site and the remains of the three halls and five smaller buildings where the Vikings lived and worked. Just a mile away, the not-for-profit Norstead Viking Village offers its own re-creation of the Norse lifestyle, including a church and blacksmith shop, constructed of wood-paneled walls and earthen floors conveying the look and feel of the Viking era.

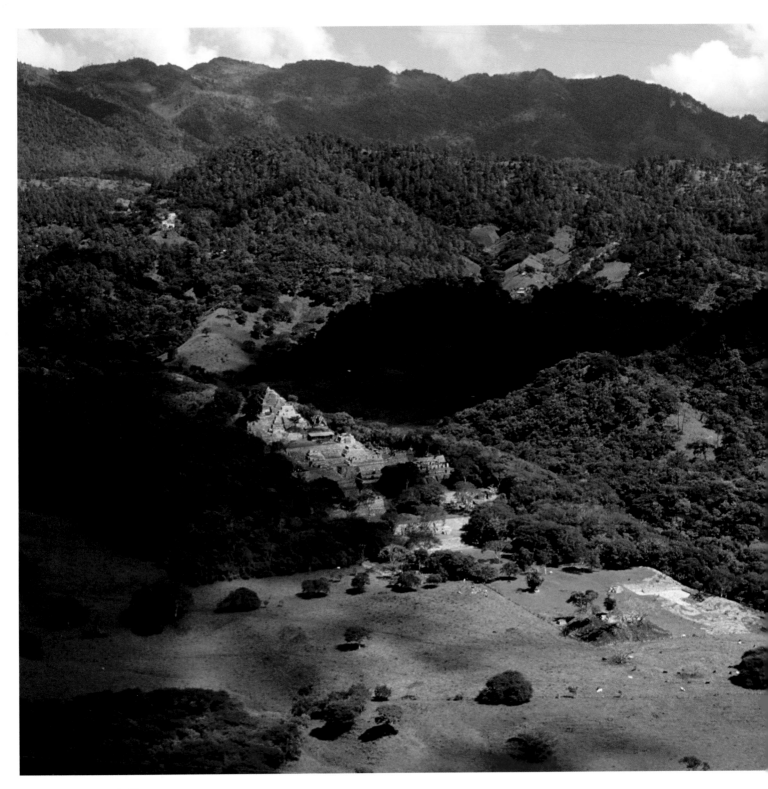

TONINA
Chiapas, Mexico

For aficionados of the Maya civilization, it is hard to beat a trip to Tonina ("house of stone," in the Tzeltal language) in the Mexican state of Chiapas, some eight miles east of the town of Ocosingo. Once the dominant Maya city in the west, Tonina's remnants now include striking groups of temple-pyramids that rise some 230 feet above what was once a court for the playing of a Mesoamerican ballgame similar to today's racquetball, as well as more than 100 carved monuments dating from the 6th to the 9th century A.D.

ISLA ESPIRITU SANTO
Baja, Mexico

Crystal-clear turquoise waters, roving bands of sea lions, cavorting dolphins and surprisingly graceful giant turtles—these are just a few of the delights on hand for visitors to Isla Espiritu Santo, a large (31-square-miles) island in the Sea of Cortez just 12 miles east of La Paz, in the Mexican state of Baja California Sur. Blessed with dozens of lovely bays like this one, Espiritu Santo is easily navigated by kayak and other non-disruptive craft that bring visitors up close and personal with its rich assortment of marine life and avian wonders.

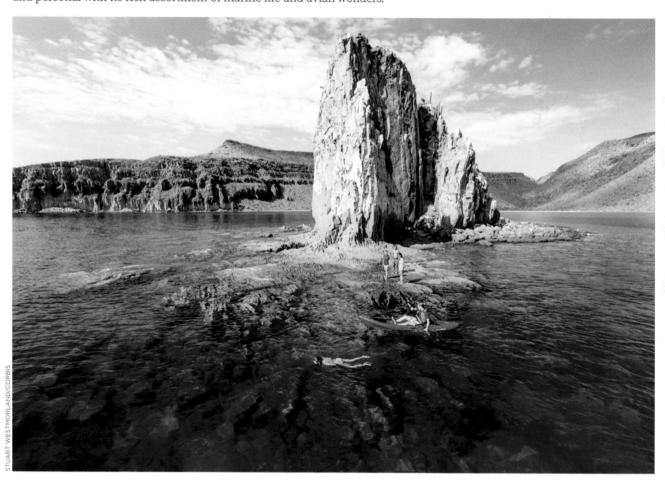

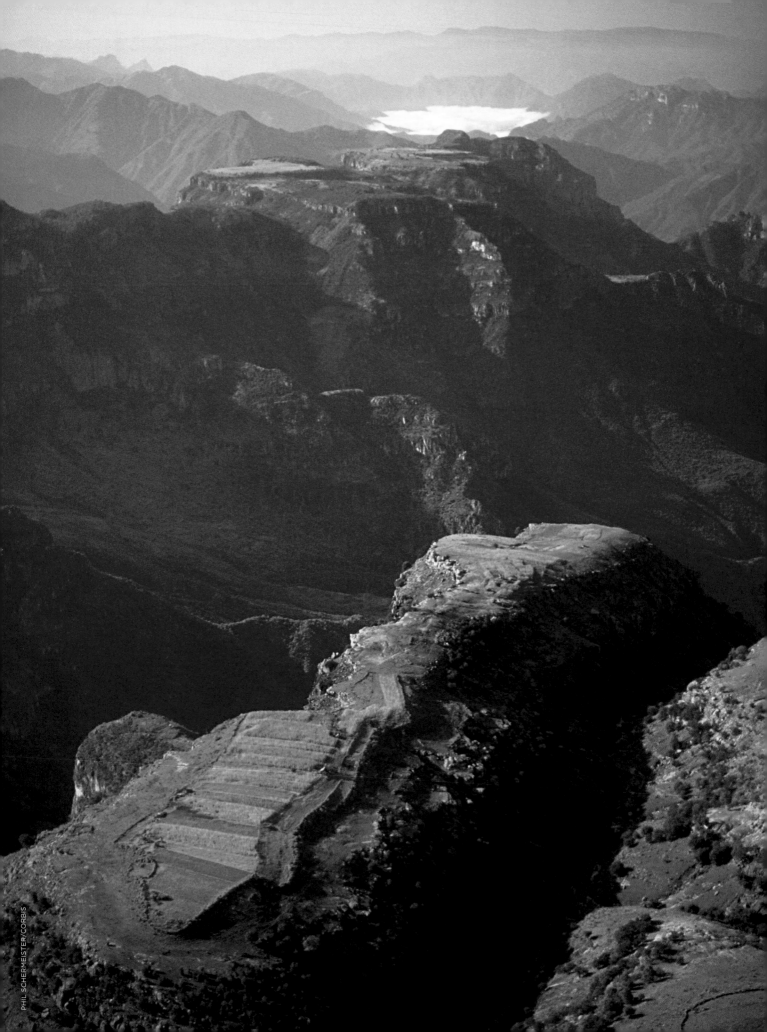

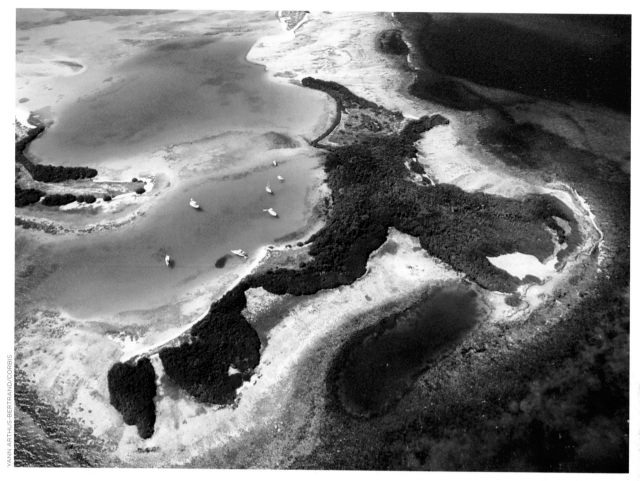

LOS ROQUES
Caracas, Venezuela

Absurdly beautiful white sand beaches, warm azure waters and a low-key undeveloped vibe to be found almost nowhere else in the Caribbean—welcome to Los Roques Archipelago, a stunning array of 350 islands, cays and islets languorously stretching its limbs 80 miles due north of Caracas. Catch one of the several flights a day on tiny aircraft that jump across the short expanse of sea to the single small island that has an airstrip and a year-round population of just 1,600 people. Hire a boat to one of the pristine islands where you may find yourself the only visitors to the beach that day. As the sun descends, hop a flight back to the mainland or spend the night in any of the several small, oftentimes funky inns that have appeared in the past 20 years or so to cater to the still small but growing number of visitors. Paradise indeed!

COPPER CANYON, Mexico

Deeper and larger than America's Grand Canyon, Copper Canyon (actually six distinct canyons) in the Sierra Madre Mountains in the southwestern part of the Mexican state of Chihuahua has become an increasingly attractive destination for visitors drawn by the dramatic views, many of them best savored from the train, the Ferrocarril Chihuahua al Pacífico, which makes its way through the main canyon and offers guided tours. Equally compelling is the still thriving culture of the indigenous people, the Rarámuri (originally called Tarahumara by the colonizing Spaniards). Some of the Rarámuri have welcomed tourism and made their villages amenable to visitors, while others have retreated to the remote reaches of the canyons where they are able to pursue their traditional lifestyle in solitude. Legendary for their ability to run vast distances nonstop up and down the trails along the canyon walls, the Rarámuri have become adept at migrating between the canyon's cooler upper climes during the summer months to the warmer temperatures along the canyon floor during winter.

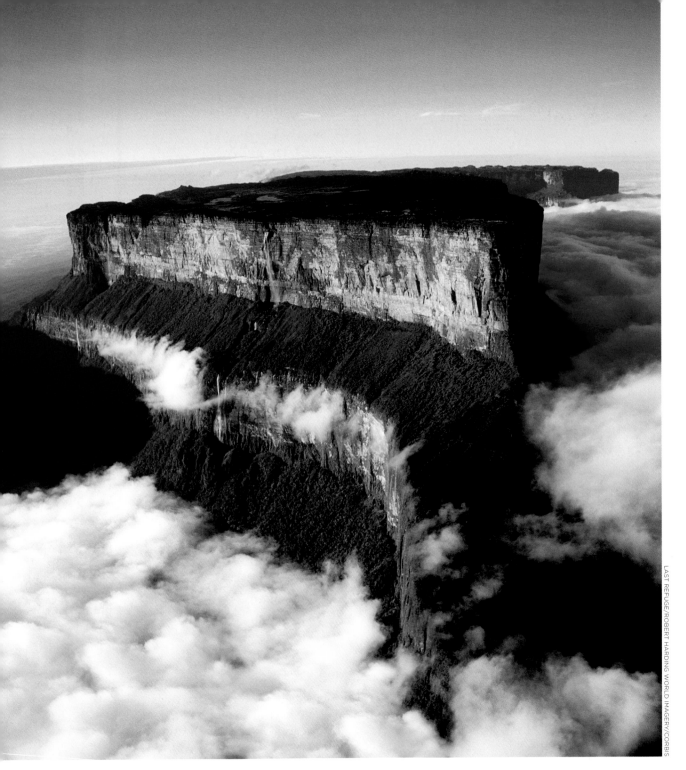

MOUNT RORAIMA
Venezuela

Fancy a strenuous but not overwhelming hike? How about a two-and-a-half-day trek up Mount Roraima, the highest of the Pakaraima chain of so-called tepui plateau (tabletop mountains) in South America? Located on the border of Guyana, Venezuela and Brazil, the 20-square-mile plateau offers dramatic vistas (to say the least), its own variants of native flora and fauna (including the Roraima Bush Toad) and surprisingly diverse terrain. Most hikers who make the ascent spend a day or two on the plateau to truly appreciate this mystical destination that served as the inspiration for Arthur Conan Doyle's *The Lost World*.

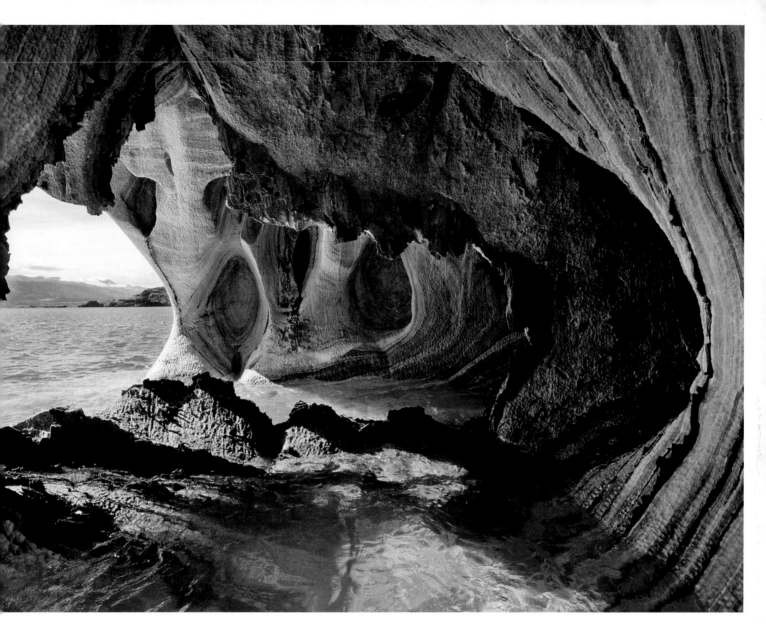

MARBLE CAVES
Patagonia, Chile

Among the world's most beautiful natural formations, the Marble Caves are located on the Chilean side of the border between Chile and Argentina, on Lago General Carrera, near the southern tip of South America. When the lake is sufficiently tranquil, visitors can take kayaks or small boats to explore the three stunning water-sculpted caverns that comprise the caves: the Chapel (La Capilla), the Cathedral (El Catedral) and the Cave (La Cueva), each with its own distinctive palette of turquoise, blue and green reflecting from the solid marble of the walls above to the crystalline waters below. Reaching this stunning natural wonder is not easy—visitors must survive a flight to Santiago, another one from Santiago to Coyhaique, and finally a serpentine 200-mile drive over challenging terrain to the lake—but the sights that await make the journey more than worth it.

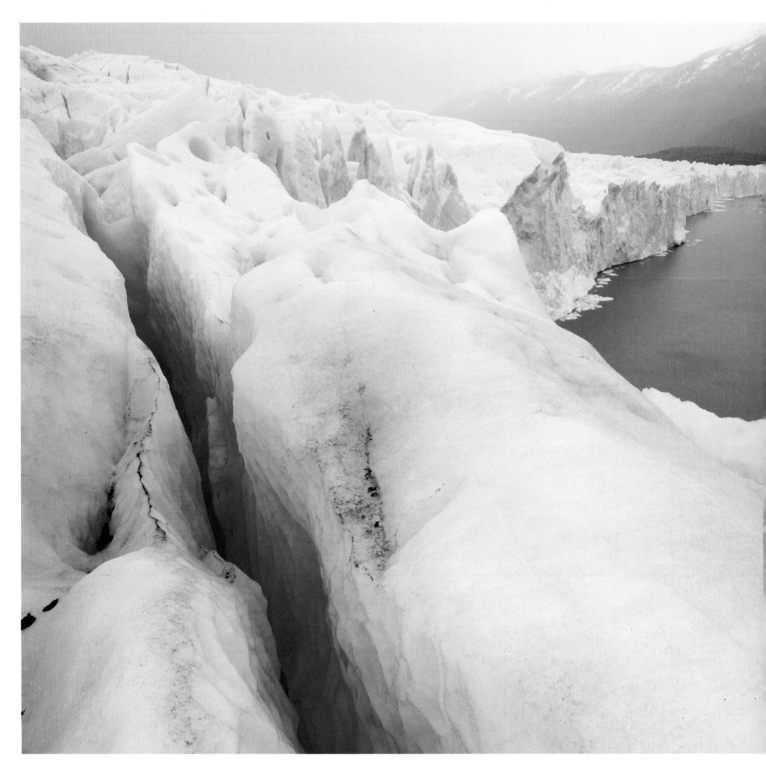

LOS GLACIARES
Argentina

If you've made it all the way to the Marble Caves featured on the previous page, you'd be foolish not to travel another 200 miles or so south, to Los Glaciares National Park in Argentine Patagonia, where monumental ice formations in the Andes, like the Perito Moreno Glacier above, comprise the largest ice cap on the globe, outside of Antarctica and Greenland. Perito Moreno is one of the only ones among the 47 glaciers in the park that can be reached by land.

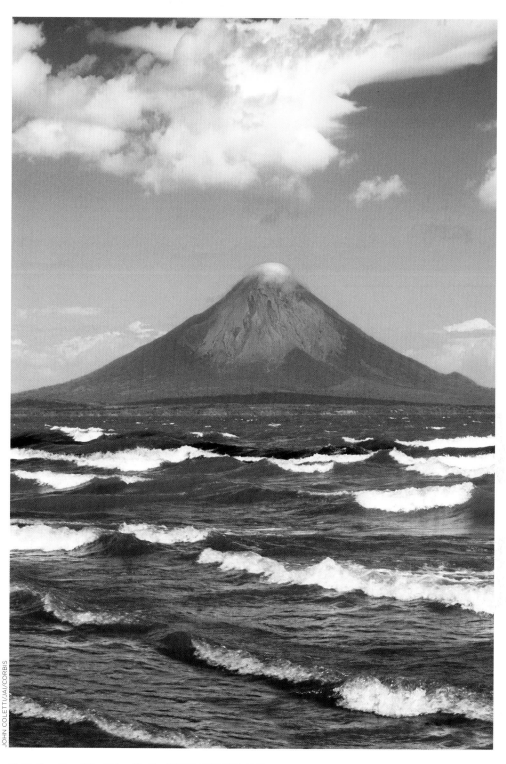

ISLA DE OMETEPE
Nicaragua

Long viewed as a holy place by the native peoples who settled it, the Isla de Ometepe was formed by a pair of volcanoes that rose out of the waters of Lake Nicaragua, including Concepción, still active, in the north. Take a volcano hike, examine the numerous pre-Columbian artifacts found throughout the island or gaze at the ancient petroglyphs or stone idols that predominate. With its rich history and varied cultural heritage, Ometepe is endlessly fascinating.

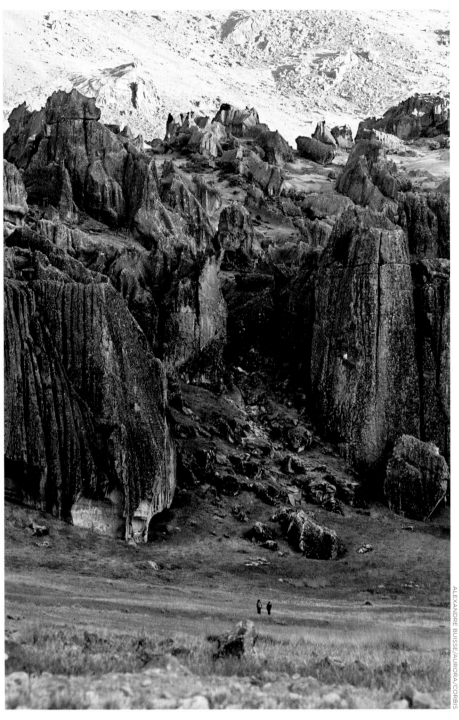

ALEXANDRE BUISSE/AURORA/CORBIS

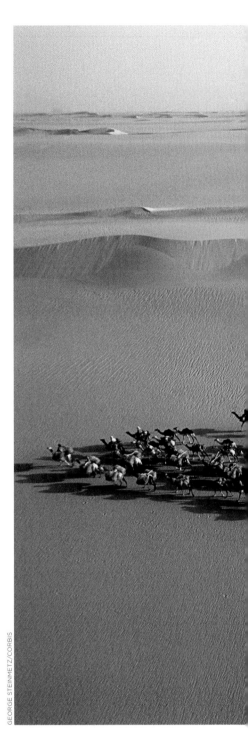

GEORGE STEINMETZ/CORBIS

CORDILLERA HUAYHUASH
Peru

Once a hideout for bandits and smugglers—not to mention the radical group Shining Path—the Cordillera Huayhuash, a relatively compact group of 20 mountains in the Andes of Peru, now offers some of the world's finest hiking, including an unforgettable 106-mile trek through and around the entire range. Take a donkey or two to carry your supplies, hire a Peruvian guide to lead you and provide invaluable local color, and you'll end up with the trip of a lifetime. Among the natural wonders in the area is the massive petrified forest of Hatun Machay.

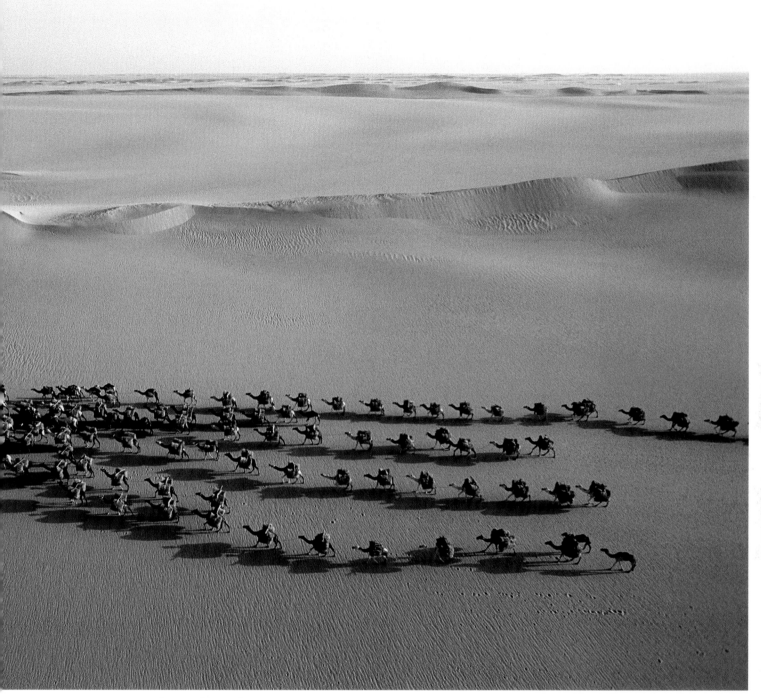

THE TÉNÉRÉ
Niger

The mode of travel through the Ténéré, the expansive desert that stretches from northeastern Niger to western Chad, remains much as it has for centuries for the Tuareg and other indigenous peoples of the region. The routes, too, remain the same, governed first and foremost by the never-ending need for water, a harsh reality that forces every journey to make the same stops at the same oases that have provided that precious resource for as long as anyone can remember. And so the hardy camels and their equally indomitable riders repeat the ancient and painstaking treks, bringing vital goods, such as salt, via caravans like this one that make the two-month round-trip to the oasis of Bilma, where local Tuareg traders will buy the salt to sell in southern Niger and northern Nigeria. Some of the oases, such as Timia, which is on the edge of the desert, can be visited, but the desert itself remains implacably obdurate, available to be admired, gazed at and, of course, flown over, but never conquered.

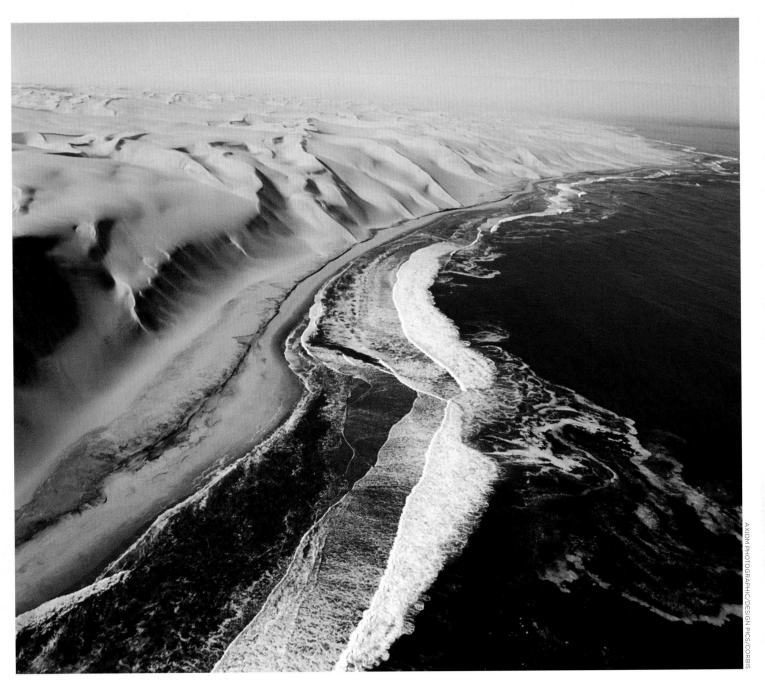

NAMIB-NAUKLUFT NATIONAL PARK
Namibia

No trip to southwestern Africa can be considered complete without a stop at the vast Namib-Naukluft National Park, which encompasses some 19,216 square miles—about the size of the states of Vermont and New Hampshire combined—and stretches from the Atlantic coast through the Namib desert and on through the Naukluft mountain range in the east. Even in the most desert-dominated parts of the park, an astonishing collection of wildlife manages to survive, including snakes, gemsbok, hyenas and jackals. Unusual climate conditions offshore produce massive fog banks that envelop the coastal portions of the desert for up to 180 days a year, along with powerful winds that shape the desert sands into towering dunes like those above.

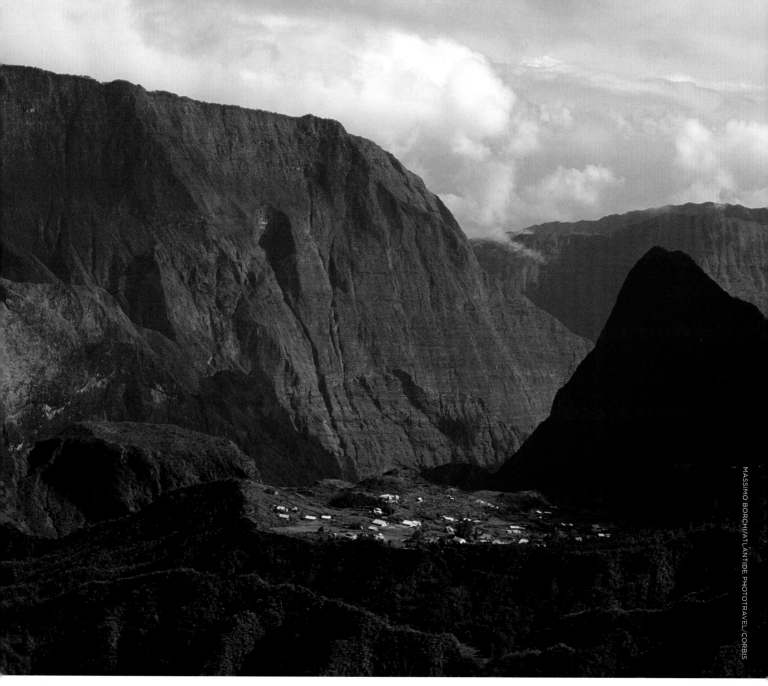

RÉUNION ISLAND
off the coast of Madagascar

As Americans, we like to extol the virtues of the melting pot, the favored image for the great experiment in ethnic intermingling so important to U.S. history. But nowhere has that concept been more fully embodied than on Réunion Island, a vestige of French colonialism, which was first discovered by the Portuguese around 1507, then claimed by France some 130 years later. Over the centuries since, this formerly uninhabited island in the Indian Ocean east of Madagascar has welcomed immigrants from Europe, Africa, China, Malaysia and India, all living together peacefully on an island of only 970 square miles. Intermarriage has become common, French remains the universal language (along with a local French dialect called Réunion Creole), and the island continues to send representatives to the French National Assembly and Senate. Lovely beaches abound on the coasts, along with steep mountains in the island's interior associated with the two volcanos—one of them quite active—that helped to create the island in the first place. While the population of some 800,000 people tends to be clustered in communities near the lowland coast, some smaller villages do exist inland, like this one in a mountain canyon. If you're considering a visit, be sure to avoid the rainy—sometimes *very* rainy—season from November to April.

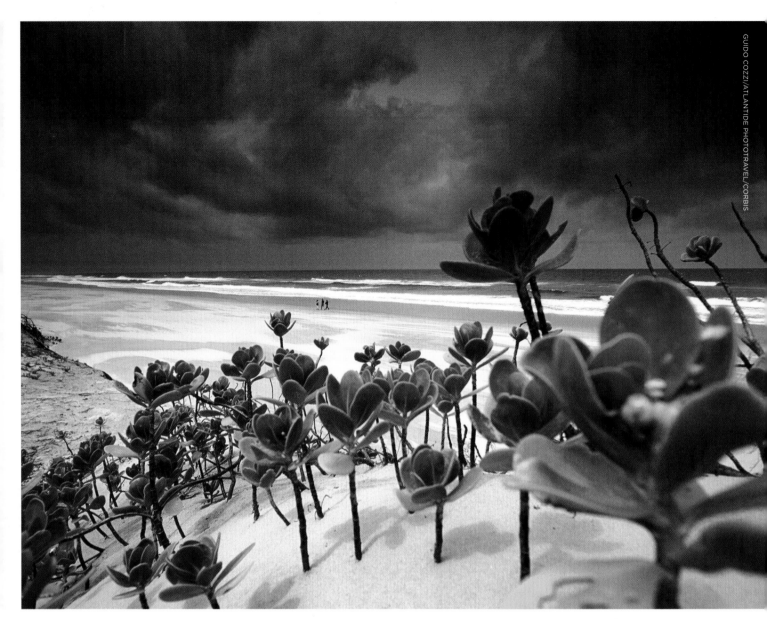

BAZARUTO ISLAND
Mozambique

Perhaps you're not looking to tax your body or your intellect; you just want to settle in to the lap of luxury and relax. If that's the case, you'd be hard pressed to find a more ideal destination than Bazaruto Island, in the Indian Ocean off the coast of Mozambique. Blessed with warm, tranquil waters, palm trees, pristine, white sand beaches and luxurious resort accommodations to cater to your every whim, Bazaruto also boasts excellent fishing, bird watching, snorkeling and diving, but why move if you don't have to?

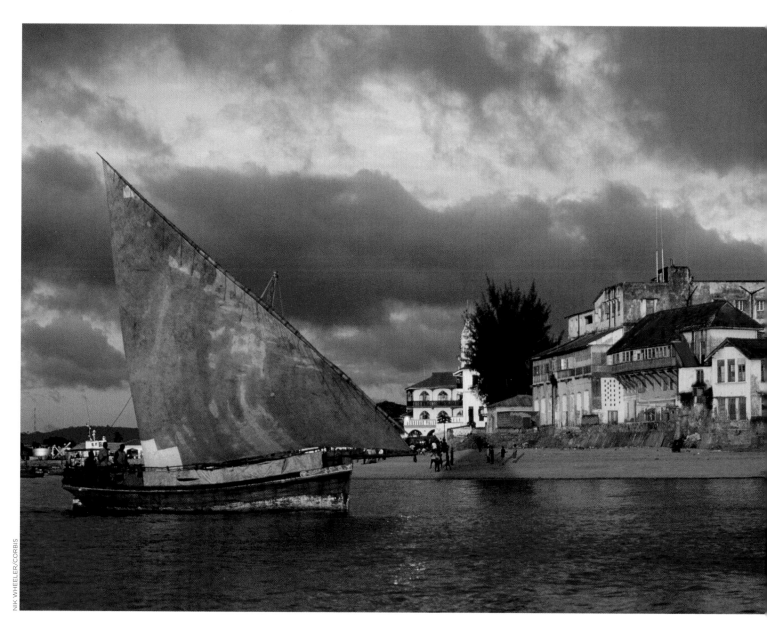

ZANZIBAR
Tanzania

In the Indian Ocean off the coast of Tanzania sits a series of islands, the largest of which is informally known as Zanzibar. With temperatures consistently in the 70s and 80s throughout the year, beautiful warm blue waters and numerous luxurious accommodations, Zanzibar is a vacation paradise. Go snorkeling. Simply bask on the beach. Explore charming Stone Town, with its huge open-air market and its fascinating blend of Moorish, Middle Eastern, Indian and African traditions. Even consider taking a ride on one of the many dhows, like the one here, that offer visitors a chance to experience this ancient mode of travel.

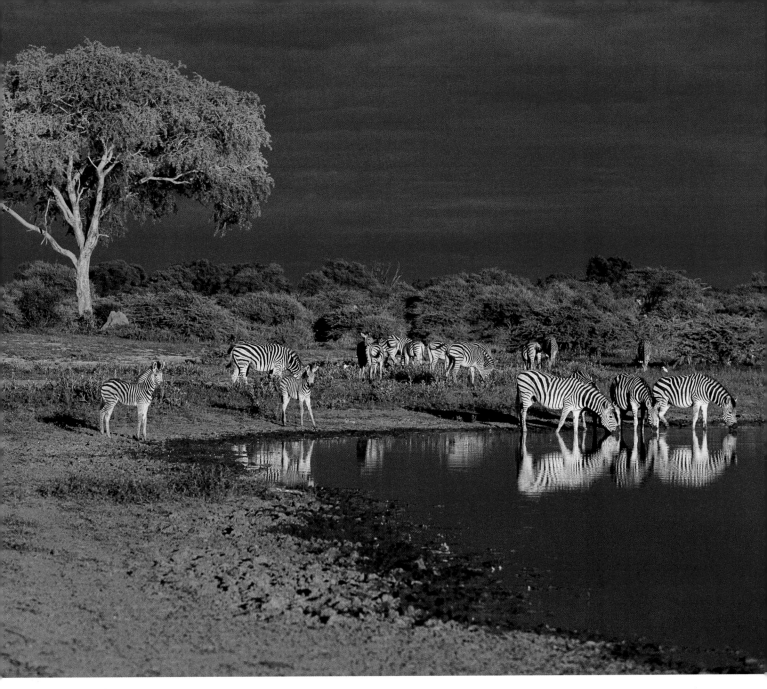

OKAVANGO DELTA
Botswana

Happy zebras drink the water and graze on grass produced
by the seasonal flooding of the Okavango River that deposits
massive amounts of water across the 155-by-93-mile area of the
Okavango Delta from March to June. Ultimately all the water
is either consumed or taken up by evaporation or transpiration,
leaving the area parched until the river rises again the following
year. During the high-water period, visitors to the area are
privileged to witness one of the most bounteous arrays of wildlife
in all of Africa, including 400 varieties of bird in addition to
elephant, buffalo, hippopotamus, wildebeest, lion, cheetah, leopard,
giraffe, hyena and a potpourri of gazelle and related species.

NAMAQUALAND
South Africa

If you're considering a trip to South Africa
during that country's spring (September
to November), a visit to Namaqualand, an
enormous, normally arid region in North Cape
Province, is an absolute must. It's then that the
landscape explodes in an almost miraculous
display of color, the result of millions of
wildflowers, like these in the Goegap Nature
Reserve, blooming simultaneously.

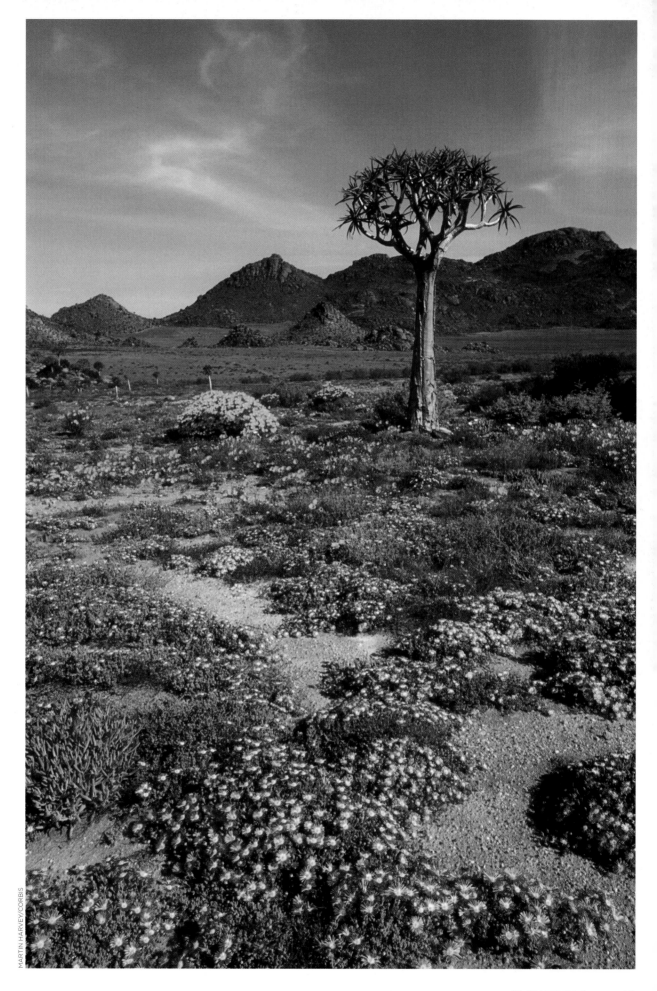

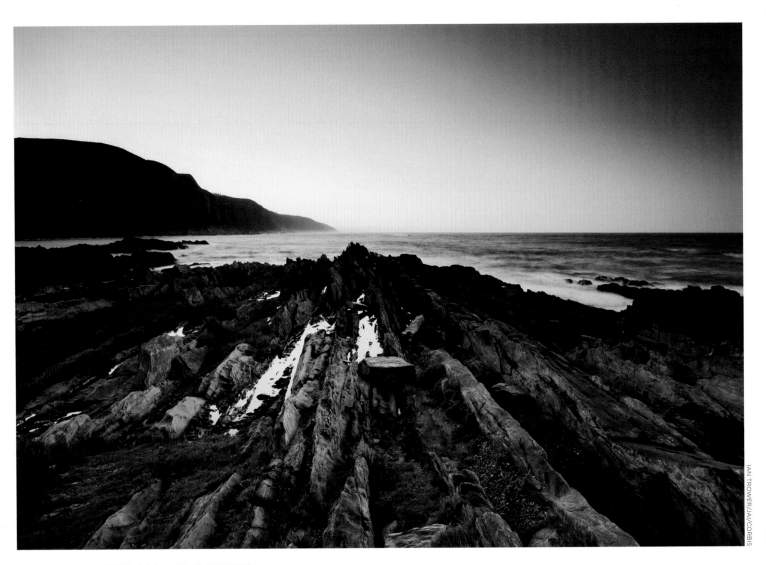

IAN TROWER/JAI/CORBIS

GARDEN ROUTE
South Africa

There are few more beautiful stretches of terrain in the world than the so-called Garden Route in southeastern South Africa, near the continent's very tip. Sandwiched between the Indian Ocean and the Outeniqua and Tsitsikamma mountains just slightly inland, the Garden Route offers stirring views of the diverse, sometimes spectacular vegetation that gave the route its name, as well as tantalizing peeks at lagoons and lakes and, of course, the ever-present sea. Along the way, in one of the many bays that punctuate the journey, you might spot a dolphin, a seal or even a Southern Right Whale. Most explore the route by car on fabled route N2, which snakes its way along the coast from Mossel Bay to Storms River Mouth (above), with its dramatic outcroppings that jut into the open ocean.

AKUREYRI
Iceland

In northern Iceland, just a 45-minute flight from Reykjavik, sits the picturesque port town of Akureyri. Located beside the azure waters of Iceland's longest fjord and blessed with snow-capped mountains, lush farmlands and perfectly preserved period houses, Akureyri offers visual delights around every corner. Though the summer months are the best time to visit, Akureyri boasts one of the warmest climates (annual mean temperature of 38 degrees) in Iceland due to the mountains that shield it from the region's harsh winds.

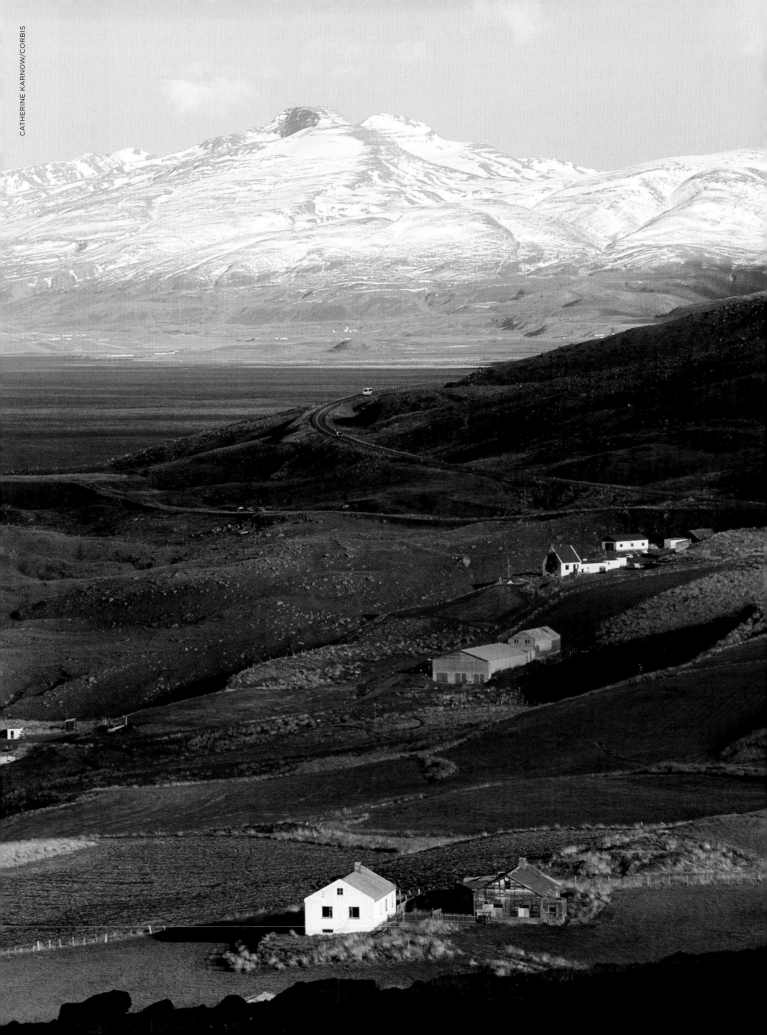

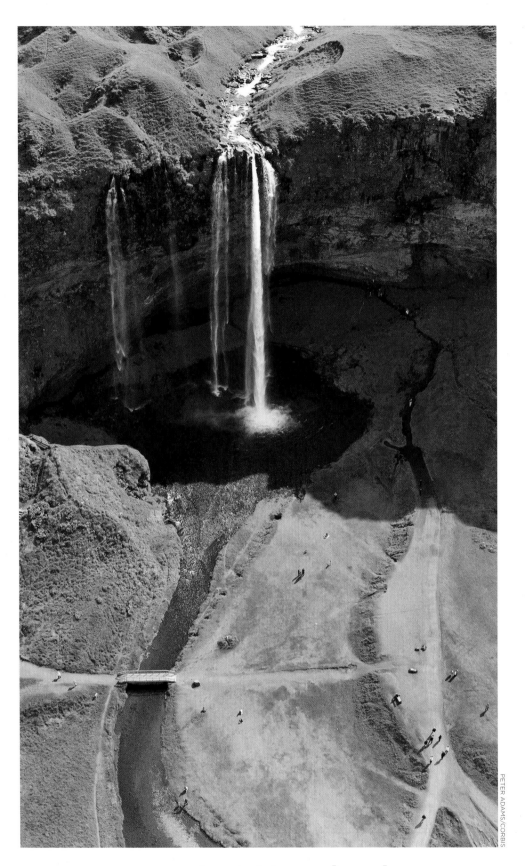

SELJALANDSFOSS, *Iceland*

One of the world's most famous waterfalls resides near Hvolsvöllur on the southern coast of Iceland, drawing visitors from near and far to its dramatic 200-foot cascade. The best vantage point may be from the trail that snakes behind the falls and allows viewers to get up close and personal with the waters tumbling right in front of their faces.

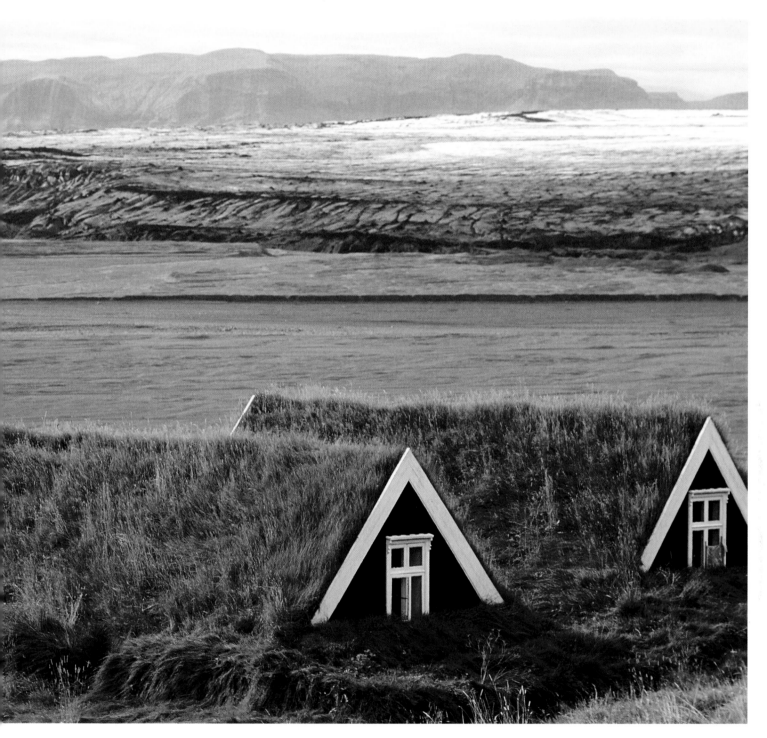

SKAFTAFELL HOUSES
Iceland

These charming, tiny turf houses are located inside Iceland's Skaftafell National Park—part of Vatnajokull National Park since 2008—one of the world's most desirable destinations for hikers and nature enthusiasts drawn by the park's stunning glaciers, crystal caves and cascading waterfalls. Built in 1912 into the side of a hill overlooking the park and its many glaciers and the rivers that run from them, the houses include upper floors, visible here, which contain the farm family's living quarters, and lower floors, only visible from the houses' other side, that once housed livestock. Last inhabited in 1946, the houses have been under the care of the National Museum, which restored them in 1972.

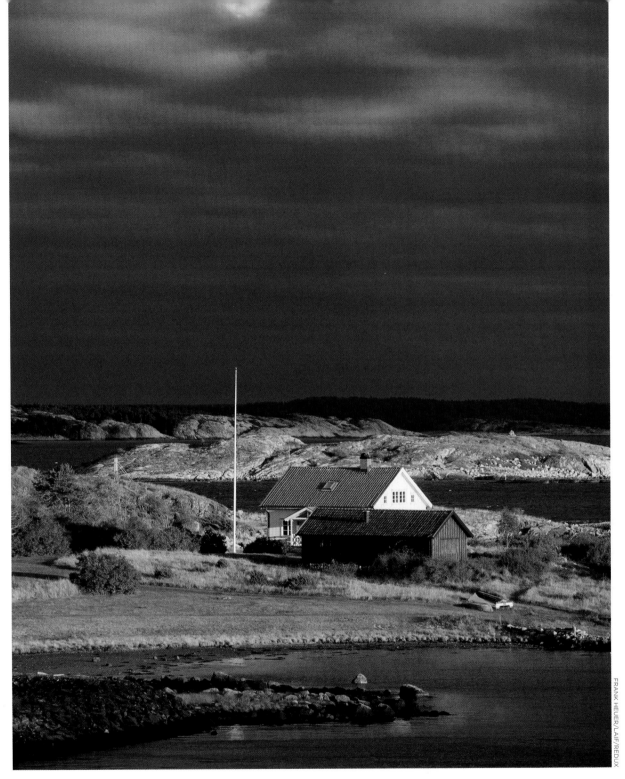

SOUTH KOSTER ISLAND
Sweden

One of Sweden's most popular tourist destinations, drawing 90,000 visitors annually, South Koster Island is part of an archipelago situated some six miles off the coast of Strömstad in southern Sweden. Charm abounds in this unspoiled territory, with a combined population of 340 people on South Koster and the smaller North Koster Island, located across a watery expanse of just 190 feet. Take the 45-minute ferry ride from Strömstad, enjoy the beaches, hike the many inland trails or grab a bicycle or golf cart and explore the extensive network of roads and pathways at your leisure. With breathtaking views of the North Sea ever at hand, it's all a pleasure.

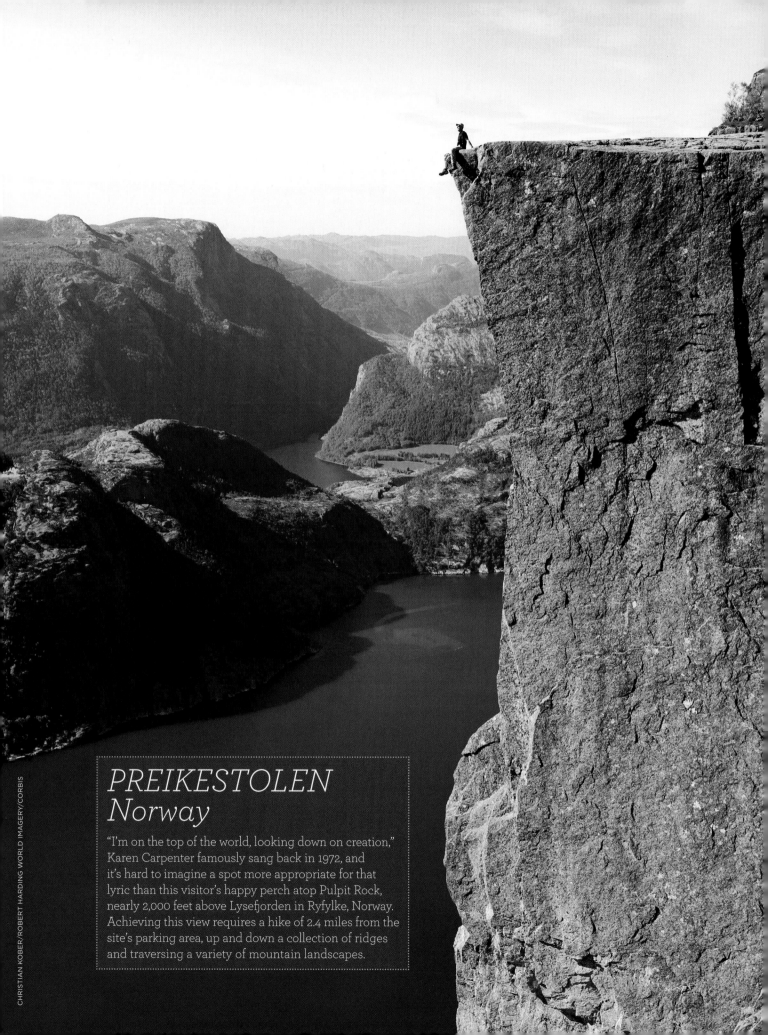

PREIKESTOLEN
Norway

"I'm on the top of the world, looking down on creation," Karen Carpenter famously sang back in 1972, and it's hard to imagine a spot more appropriate for that lyric than this visitor's happy perch atop Pulpit Rock, nearly 2,000 feet above Lysefjorden in Ryfylke, Norway. Achieving this view requires a hike of 2.4 miles from the site's parking area, up and down a collection of ridges and traversing a variety of mountain landscapes.

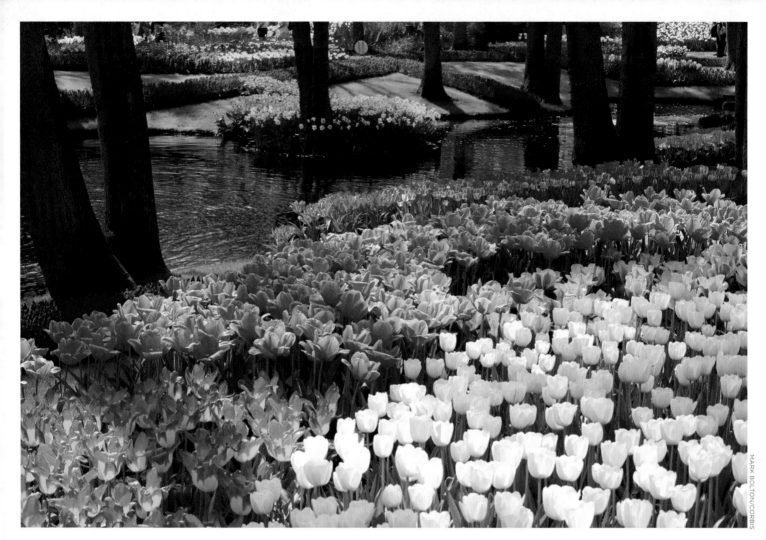

KEUKENHOF GARDENS
Netherlands

Flower enthusiasts—indeed, lovers of beauty in general—flock
every year to Keukenhof Gardens, in tiny Lisse, 21 miles
southwest of Amsterdam. The gardens are open only from
March until May, so plan accordingly. Established in 1949 as a
means for growers from all over the Netherlands and greater
Europe to display their newest hybrids, the 79-acre gardens are
the largest in the world—fitting for the Netherlands, which is the
world's largest flower exporter—and require a planting of seven
million bulbs a year that yield an unimaginable profusion of
color. The advice here is simple: Don't miss it!

SKELLIG MICHAEL
Ireland

The ruins of an ancient monastery still stand on a
tiny island hard by the Atlantic Ocean seven miles
off the coast of County Kerry in Ireland. A visit to this
cold and forbidding place, with nothing but rock and
sea and sky in sight, transports the visitor back to the
time a hardy sect of monks first took possession of the
uninhabited island at some point between the sixth
and eighth century A.D. The ferry from the mainland
will take 50 minutes and another 600 steps through
the craggy terrain will bring you to the ruins. En route
you might hear the screech of a gannet or catch a
glimpse of spume from a joyous dolphin. One can
only imagine what prayers such sights might have
inspired in the island's ancient inhabitants.

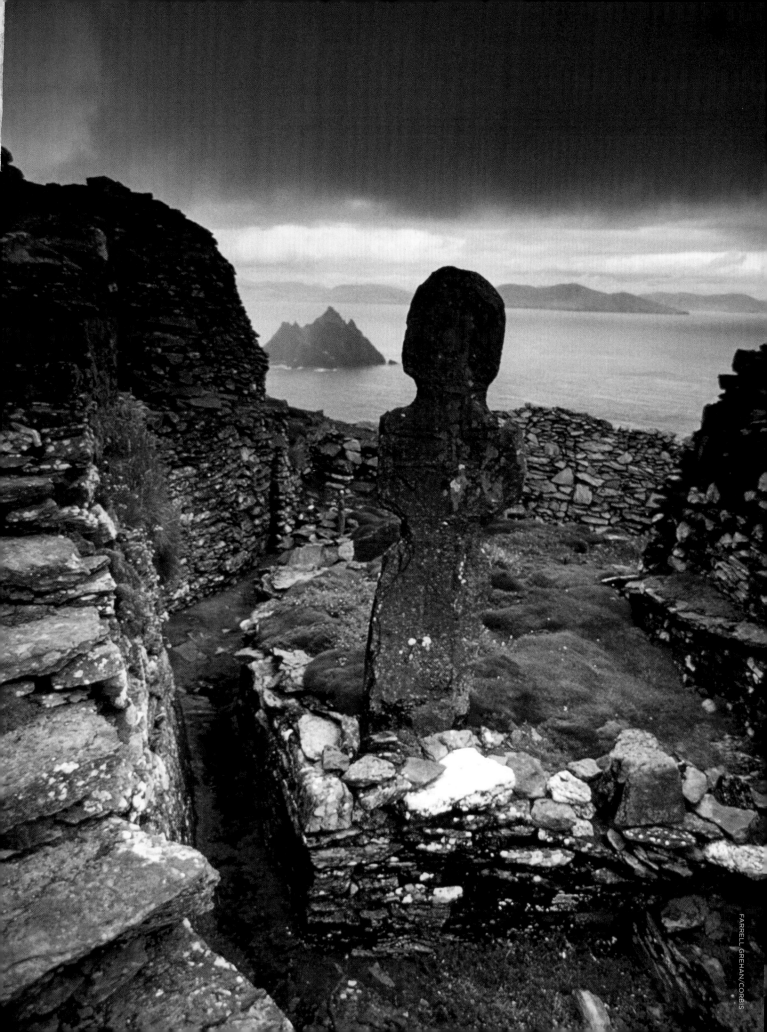

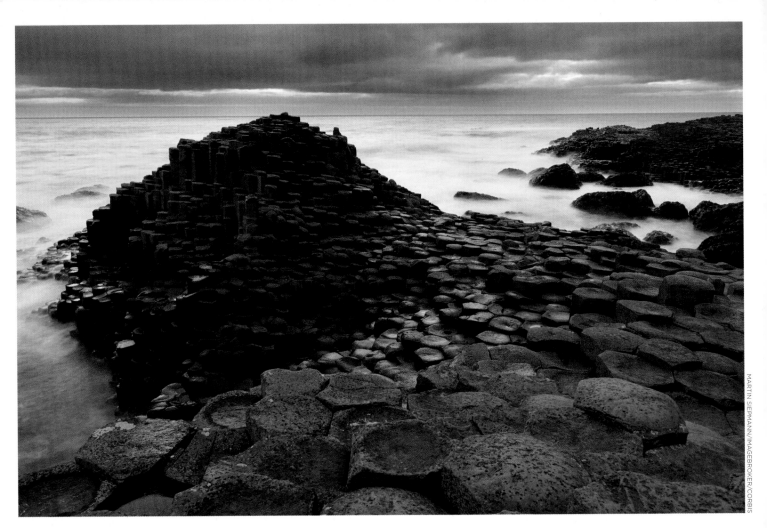

GIANT'S CAUSEWAY
Northern Ireland

With enormous steps emerging from the sea and ascending to the
foot of the cliffs, one can almost imagine the sort of gargantuan being
that might have trod such a path and given its name to this popular
tourist attraction off the northeast coast of Northern Ireland. One
ancient legend suggests that the "causeway" once linked Northern
Ireland and Scotland, until a Scottish giant named Benandonner, duped
into overestimating the size of his Irish opponent named Finn McCool,
fled in terror back to Scotland, ripping up the causeway behind him as
he went, leaving only the part now visible at the Irish end of the route.
Alas, such fanciful tales fall victim to scientific scrutiny: The "steps" are
actually composed of 40,000 interlocked basalt columns—most of them
hexagonal in shape—produced by extensive volcanic activity in the
area some 50 to 60 million years ago.

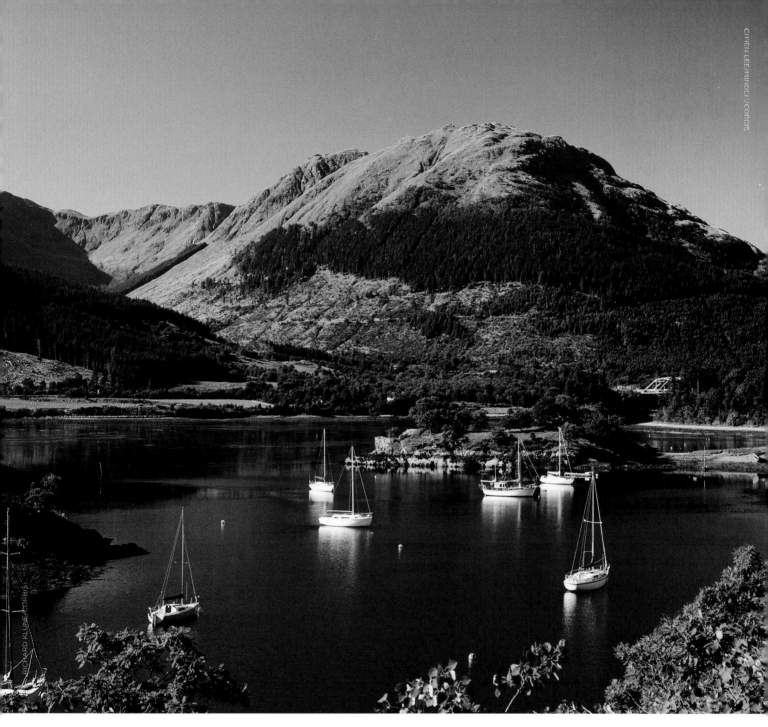

GLEN COE
Scottish Highlands

Tucked away in the Scottish Highlands, Glen Coe—
"glen," for the uninitiated, refers to a narrow valley—
is widely considered one of the most beautiful
regions in all of Scotland. Its myriad charms include
spectacular views of the surrounding mountains,
many of which can be comfortably explored by
hikers in all seasons; serene lochs, for fans of boating
and fishing; and numerous sites associated with
ancient legends as well as more reliably historical
events—the massacre at Glen Coe, which led to the
slaughter of 38 members of the MacDonald clan in
1692, is in the lexicon of every Scottish schoolboy.

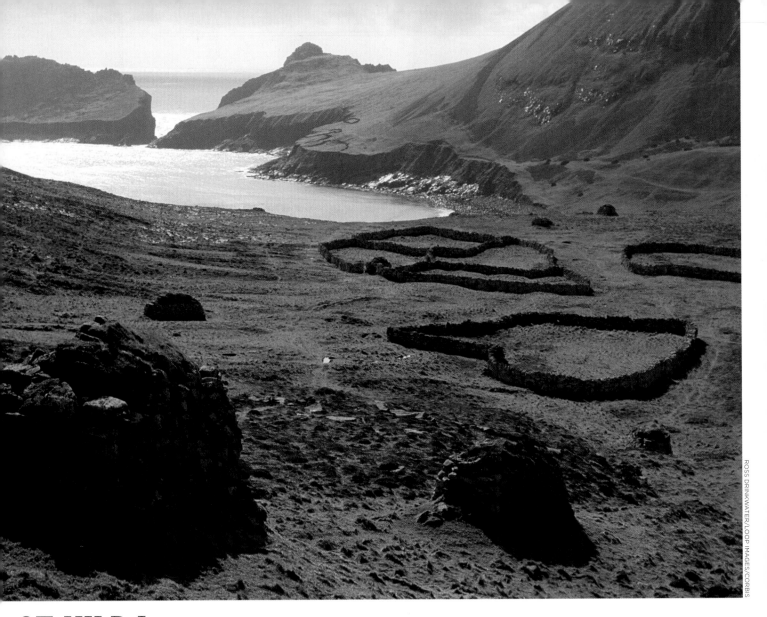

ST. KILDA
Outer Hebrides, Scotland

There is no more remote destination in the British Isles than St. Kilda, a barren archipelago that forms the western edge of Scotland's Outer Hebrides. The harsh, isolated conditions led to a rapid decline in the population in the 20th century and the complete evacuation of the islands by 1930, but numerous reminders of human civilization endure, many of them lovingly restored by the Scottish National Trust, like this cleit (stone hut) and these stone enclosures that once were used to keep sheep. (A species of wild sheep unique to St. Kilda continue to live on two of the islands.)

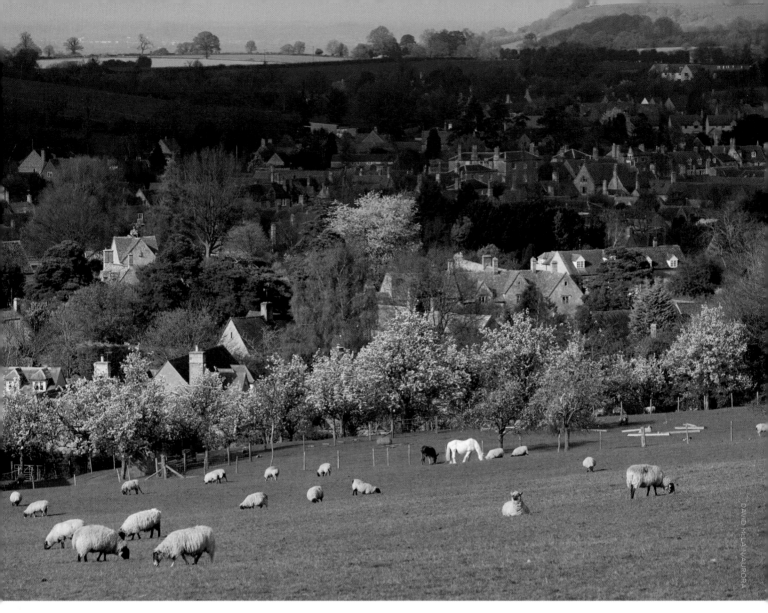

DAVID McLAIN/AURORA

COTSWOLD WAY
Somerset, England

One of Great Britain's official National Trails, the 102-mile Cotswold Way meanders happily along the escarpment of the Cotswold Hills in southern England, offering hikers a gentle walk through some of the loveliest terrain in the world. Starting in the south, near Bath, and running up to Chipping Campden (above), the trail passes by the Neolithic burial chamber at Belas Knap, Sudeley Castle near Winchcombe, Hailes Abbey, Gloucester Cathedral and a charming collection of churches and historic houses, not to mention an array of rolling hills and dales and rivers, including the Forest of Dean, the River Severn, the Welsh hills of Monmouthshire, May Hill and the Malvern Hills. Organized walking tours, with experienced guides and all the essentials of food and lodging taken care of, remove all the stress, leaving you to focus on the fun.

ROYAL BOTANIC GARDENS, KEW
London, England

Kew Palace, designed in 1631 by Samuel Fortrey and fashioned from nearly flourescent red brick, stands adjacent to the Royal Botanic Gardens, Kew, often referred to as Kew Gardens, home to the world's largest collection of living plants (more than 30,000 different kinds) spread over nearly 300 lush acres. The palace, which requires a separate admission fee, is the smallest but surely one of the most elegant of the British royal palaces. Its most recent claim to fame was as the site of the dinner hosted by Prince Charles to celebrate Queen Elizabeth's 80th birthday in 2006.

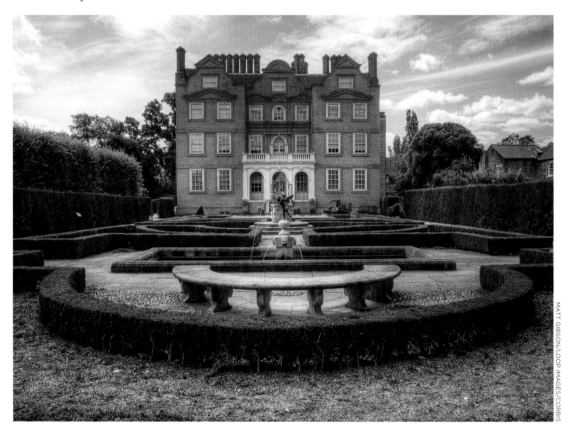

MATT GIBSON/LOOP IMAGES/CORBIS

JOSÉ FUSTE RAGA/CORBIS

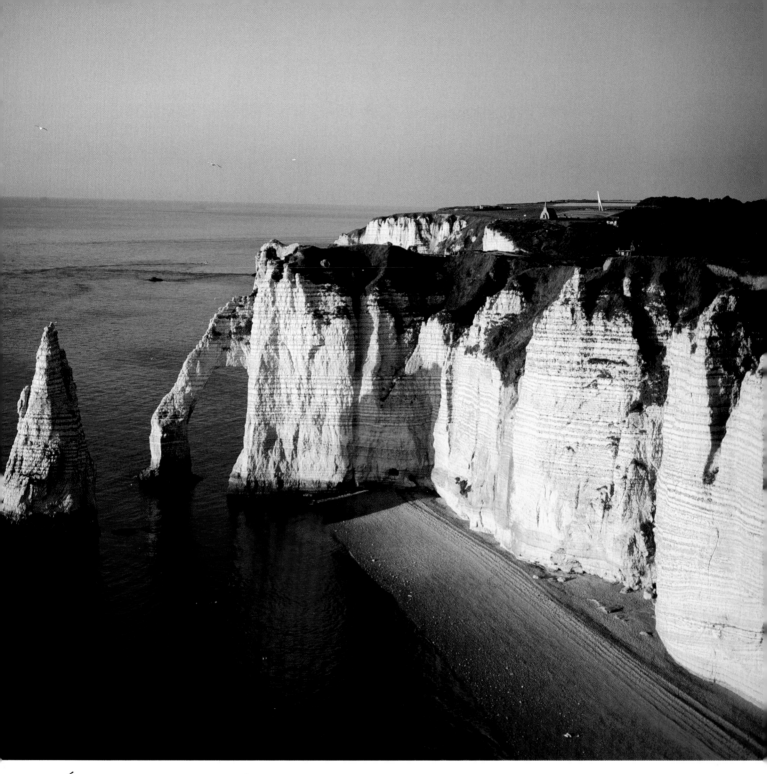

ÉTRETAT
Normandy, France

It is easy to see why iconic artists like Claude Monet and Gustave Courbet would have been drawn to these dramatic cliffs near the tiny village of Étretat, in northern France. The village itself, largely supported by farming and tourism, is charmingly unspoiled, but the cliffs are the real attraction, rising in a sheer face some 230 feet above the waves of the English Channel and mirroring the legendary white cliffs on the channel's opposite shore. It doesn't require a child's fanciful imagination to see the elephant popping its head out of the rock and dipping its trunk in the water, does it?

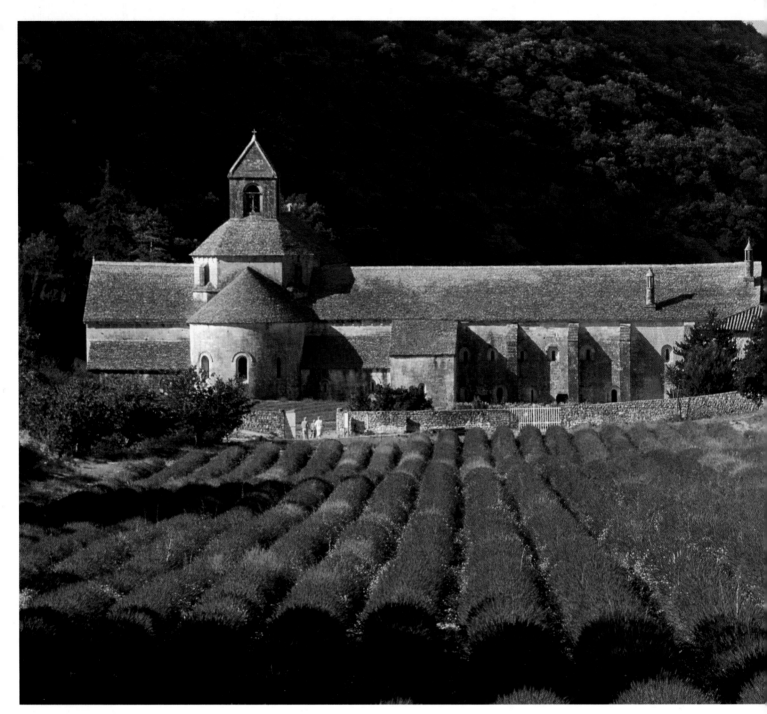

SÉNANQUE ABBEY
Provence, France

A magnificent and well-preserved example of Romanesque architecture, the
Sénanque Abbey has occupied this spot near the village of Gordes ever since
Cistercian monks founded the monastery in the 12th century. The church, formed
in the shape of a tau cross, and its surrounding buildings have experienced their
share of vicissitude through the centuries, but now they are home once again to a
small group of Cistercian monks associated with the Lérins Abbey, who support
themselves by tending honey bees and growing radiant lavender like the crop above.
In addition to welcoming casual visitors, the abbey also hosts spiritual retreats for
groups and individuals wishing to stay for more extended periods of time.

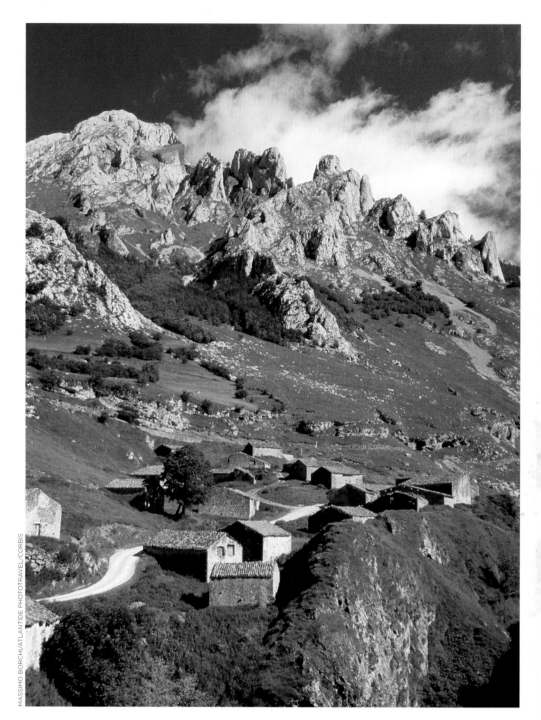

PICOS DE EUROPA
Pandebano, Spain

Imagine trekking through the picturesque Picos de Europa ("Peaks of Europe"), a wondrously accessible range of mountains just 12 miles from the northern coast of Spain. Now imagine coming across this tiny village called Pandebano, nestled in the foothills, along one of the only roads that traverses this mountainous region, inhabited by Spaniards raising their crops and tending their flocks as they have for centuries. Could anyone blame you if for just a moment you imagined a different life and a different time?

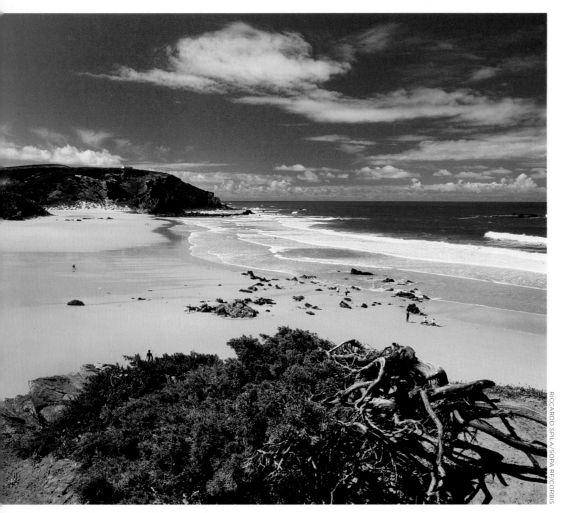

PRAIA DO AMADO
Algarve, Portugal

No trip to Portugal could be considered complete without a visit to its southern coast, home to several of the world's most enchanting beaches, like this one, Praia do Amado, near Vila do Bispo in the southwestern corner of Portugal in the Algarve district. A favorite spot for surfers and sun worshippers alike, the beach—and there are others like it stretching east some 75 miles to Faro—offers the perfect antidote for tired tourists in need of a spot to recharge their energies.

CHÂTEAU DE VILLANDRY
Loire Valley, France

Gorgeous, meticulously tended gardens draw visitors from all over Europe to this 16th-century chateau and grounds in the Loire Valley in central France. The chateau itself is one of the last of the classic Loire chateaux, but one of the first to resist Italian influences and medieval decorative details in favor of a simpler, more elegant, distinctively French style. The design is a model of architectural symmetry, a value also reflected in the mesmerizing patterns of the low box hedges that lead the way to it.

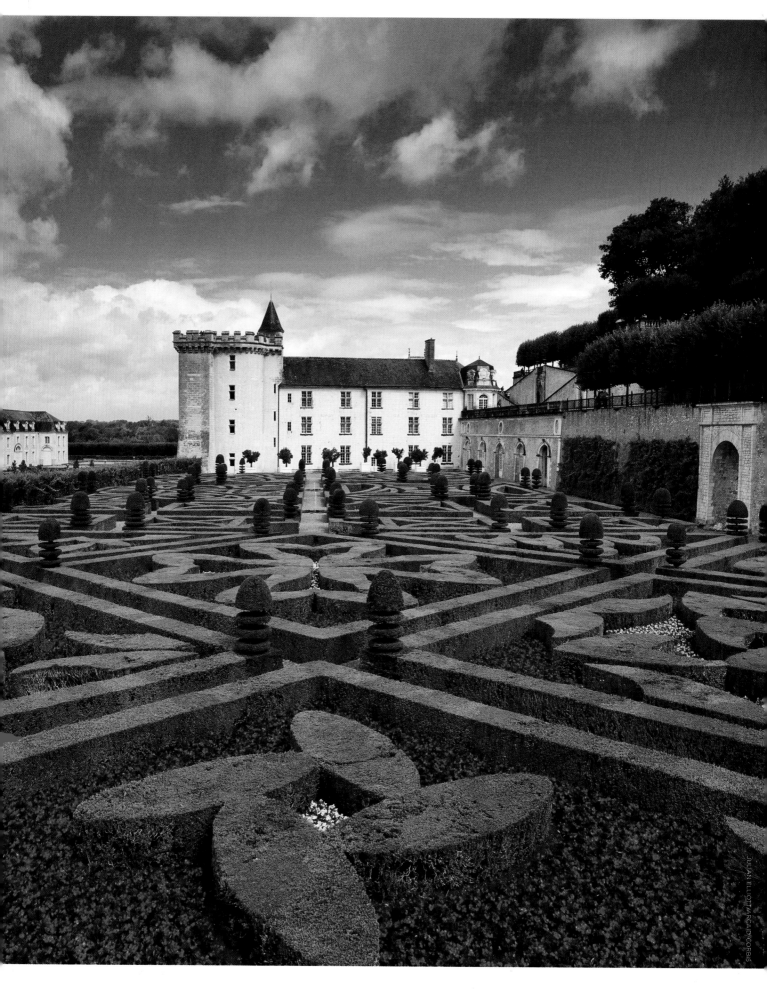

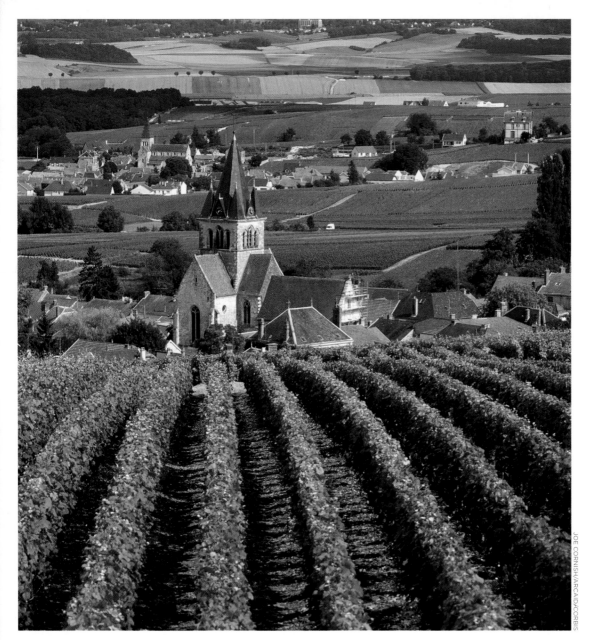

JOE CORNISH/ARCAID/CORBIS

SIMON HARRIS/ROBERT HARDING WORLD IMAGERY/CORBIS

CHAMPAGNE-ARDENNE
France

Here are the grapes—the only grapes—that properly contribute to the production of Champagne because they are indeed happily ripening in the sun of France's fabled Champagne-Ardenne region in northeastern France. Predominantly rural, with one of the lowest population densities among France's 27 regions, Champagne-Ardenne offers picturesque villages, rolling hills and acres and acres of grapes, an astonishing bounty that yields millions of cases a year to satisfy the global thirst for the region's signature elixir.

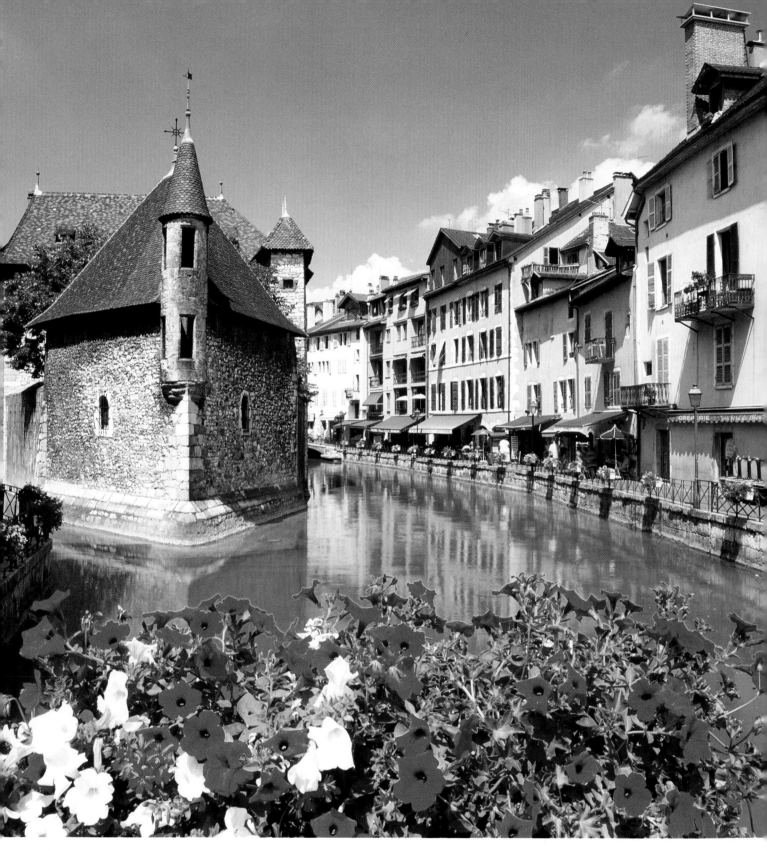

ANNECY, *France*

If you thought Venice was the only destination with water flowing through its veins, then consider Annecy, a lovely resort town in the French Alps, with water, water, everywhere, including in the canal that runs through the center of town and past the Palais de l'Isle (circa 1132), as well as in Lake Annecy on whose shores the village sits. With sensational skiing in winter—Annecy made an unsuccessful bid to host the 2018 Winter Olympics—charming streetside cafés in summer and stunning views of the mountains and lake all year round, Annecy remains largely undiscovered. Relish its picture-postcard charm before everyone else does.

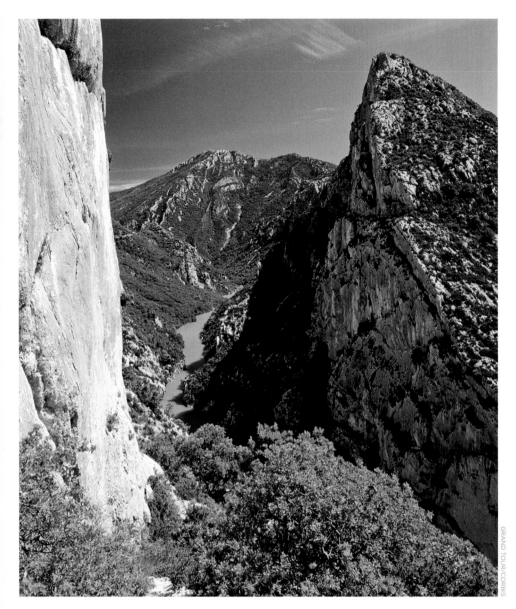

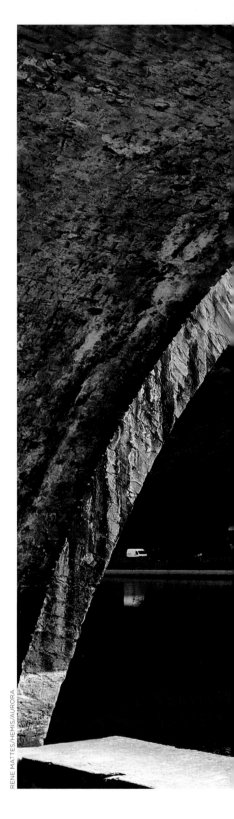

GORGES DU VERDON
Castellane, France

The blue-green of the Verdon River creates an almost shocking contrast with the surrounding deep greens of the forest and the much lighter hues of the limestone rock above it. Considered France's version of America's Grand Canyon, the Gorges du Verdon can be savored quickly with a short visit to enjoy the views, or more extensively with several days exploring the many memorable villages along the canyon's edges, including medieval Trigance, quaint Aiguines on the banks of Lac de Sainte Croix, and Moustiers-Sainte-Marie, famous for centuries for its peerless pottery.

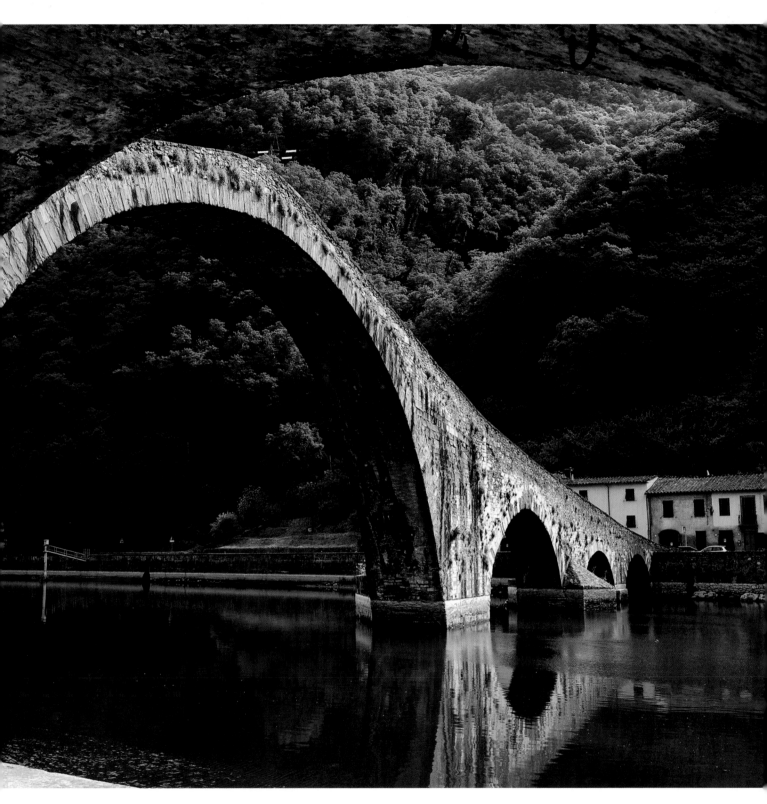

PONTE DELLA MADDALENA
Lucca, Italy

This stunning bridge, built around A.D. 1080–1100 and considered a marvel of medieval engineering, was once a critical span across the Serchio River on the Via Francigena, one of the most important pilgrimage routes of the era, linking France to Rome. Although it remains one of the most memorable sights near Lucca—a charming, ancient walled city in Tuscany and the birthplace of Puccini—the need to construct an additional arch to accommodate a paved roadway at the far end of the bridge mars the beauty of the original three ascending arches.

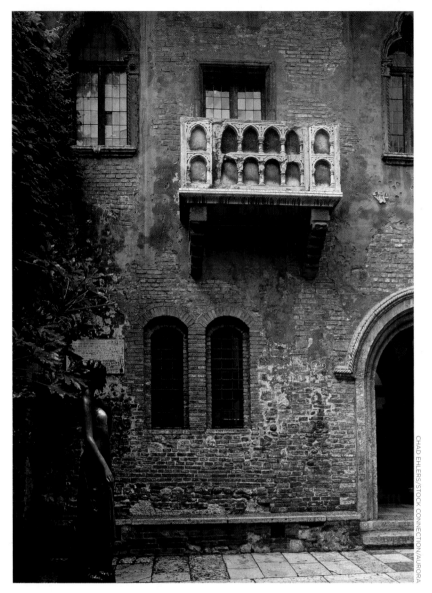

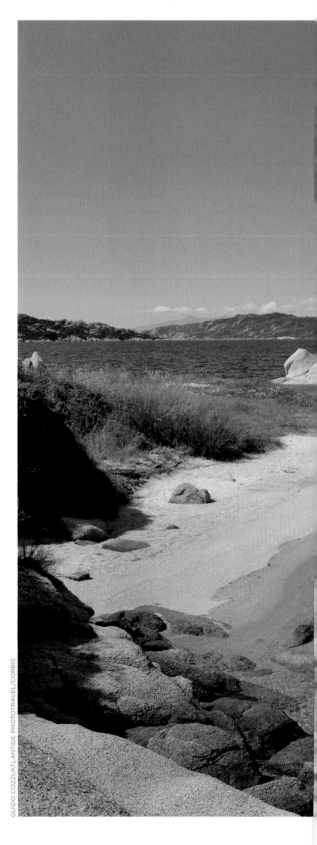

VERONA
Italy

"O Romeo, Romeo, wherefore art thou Romeo?" Juliet plaintively cries in the legendary balcony scene from Shakespeare's *Romeo and Juliet*. Might she have spoken that immortal line (or words to the same effect) from this very balcony in Verona? Probably not—evidence suggests the balcony was constructed later, perhaps as a means to attract tourists—but Shakespeare's feuding families, the Montagues and Capulets, were based on two real families vying for power in Verona, and the tale of their love-struck, star-crossed children may actually have happened. It had been recounted many times by Italian authors before Shakespeare adopted the story for his own unforgettable dramatic purposes. This house may also have been owned by Juliet's family, the Capulets (Cappelletti in Italian), and a statue honoring the family's most famous figure was erected in the 1960s. Of course, Juliet's house is just one of a panoply of pleasures awaiting those making a journey to this ancient northern Italian city. If you go in the summer months, be sure to take in an opera under the stars in Verona's world-renowned Arena, an ancient Roman amphitheater, completed around A.D. 30.

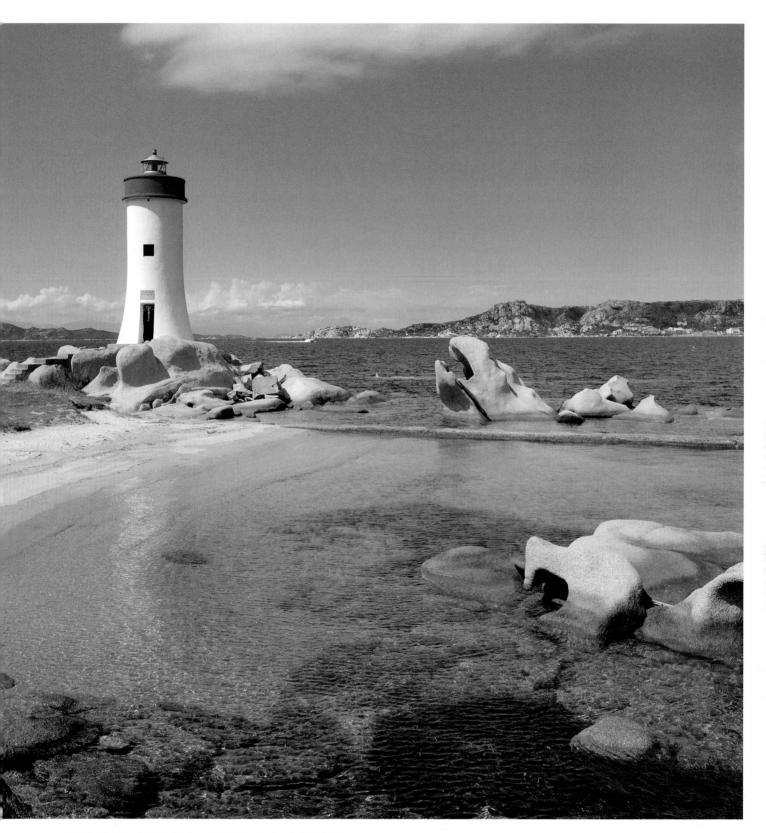

PALAU LIGHTHOUSE
Sardinia, Italy

The craggy coast of Sardinia—at 170 miles long by 90 miles wide, it is the second largest island in the Mediterranean—requires a platoon of functioning lighthouses to guide the many ships that traverse the waters in its vicinity. This one, on the northern tip of the island, flashes its warnings to the many ferries that navigate inside the Maddalena Archipelago to carry their passengers to the port of Palau.

PUGLIA
Italy

Are you one of the millions of experienced travelers whose response to another Italian destination is a weary "been there, done that" shrug? Maybe you're tired of fighting the crowds in Florence or Venice? If so, you need to consider a visit to the Puglia region, one of Italy's still undiscovered gems, located on the heel of the Italian boot. Blessed with verdant rolling hills, spectacular beaches on the Adriatic and Ionian seas and unspoiled ancient villages like Sant'Agata di Puglia, nestled in the Daunia Mountains, this is Italy unspoiled.

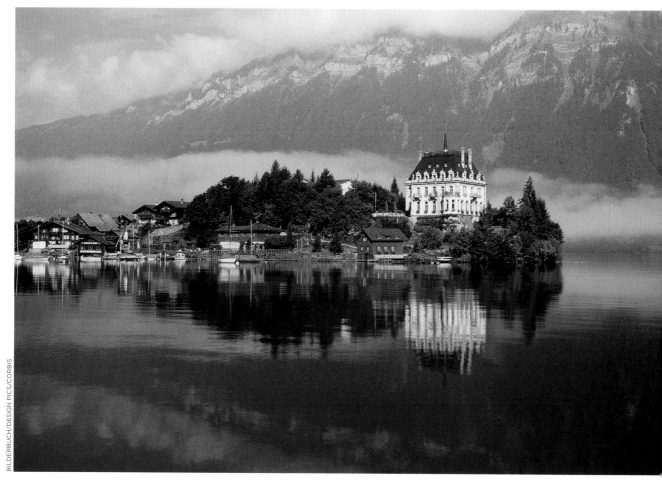

INTERLAKEN
Switzerland

The town of Interlaken, located in the Swiss Alps, first gained notoriety as a playground for pampered Europeans drawn to its mountain air and opulent spa treatments. Today, the town and the surrounding region that bears its name are better known as a base for those wishing to explore the mountains of the Jungfrau region—some accessible only to experienced mountaineers—or to enjoy the many quaint villages surrounding the two lakes on either side of Interlaken, Lake Brienz and Lake Thun. Iseltwald, on Lake Brienz, is one of the most picturesque—on misty days, its Seeburg Center and the isthmus on which it sits seem like a mountain kingdom unto itself, afloat and independent.

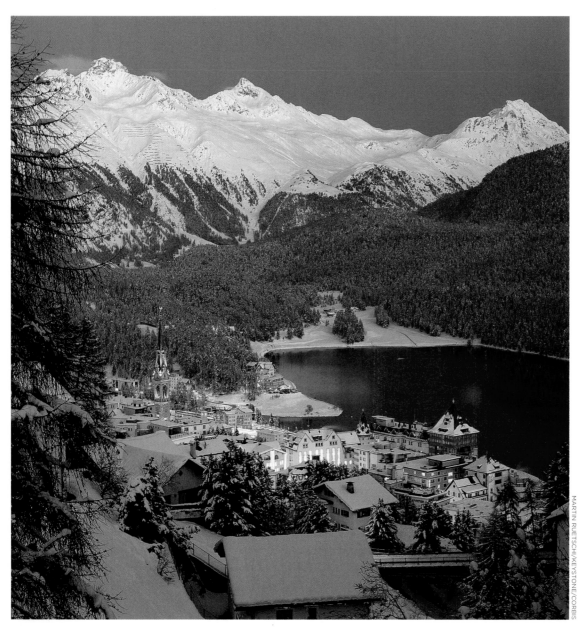

ST. MORITZ
Switzerland

With 300 days of sunshine per year, it is not surprising that St. Moritz, in southeastern Switzerland, is one of the world's most venerable and beloved resorts. Legend has it that local hotel pioneer Johannes Badrutt invited four British guests to the area in 1864 and pledged to pay for their trip if they did not enjoy the visit. The Brits were, of course, enthralled and word of this magical locale quickly spread far and wide—its reputation was only enhanced by the fact that St. Moritz would go on to host two Winter Olympics (in 1928 and 1948). Sitting 5,978 feet above sea level and surrounded by postcard-perfect snow-capped mountains, St. Moritz now boasts some of the world's most elegant hotels and most delectable cuisine. If skiing is your favored escape, it simply does not get any better than this.

MARTIN RUETSCHI/KEYSTONE/CORBIS

JOSÉ FUSTE RAGA/CORBIS

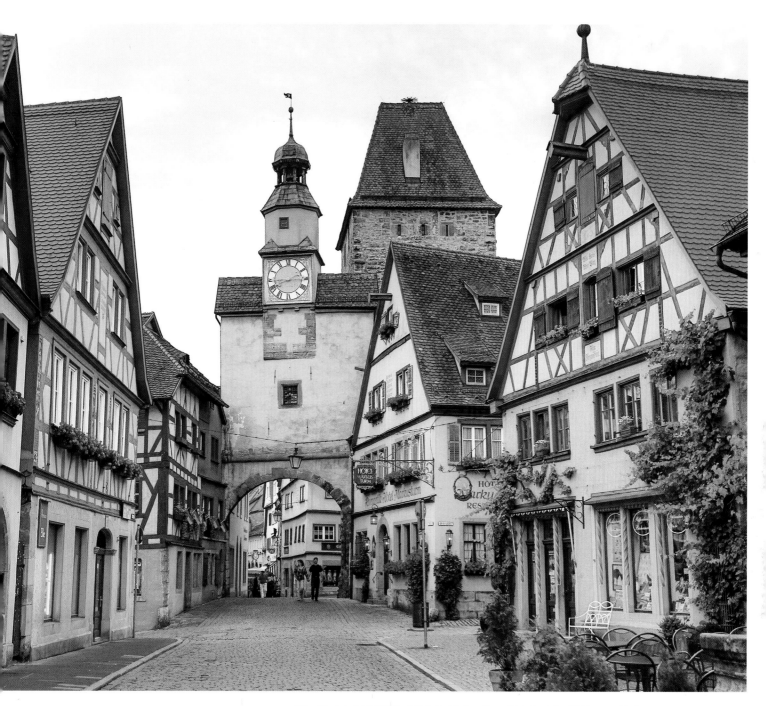

ROTHENBURG OB DER TAUBER
Bavaria, Germany

To step within the walled city of Rothenburg is to be instantly transported to the middle ages, when the city was Germany's second largest, with a population of 6,000 people. Take a walking tour if you can—it is the best way to take in the city's extensive history—and, to avoid the day-trippers that infest the city, stay overnight and walk the moonlit streets in relative solitude, marveling at just how perfectly preserved Rothenburg truly is. There may be a touch of the theme park about the place, but in fact there is no more authentic peek at medieval life to be had.

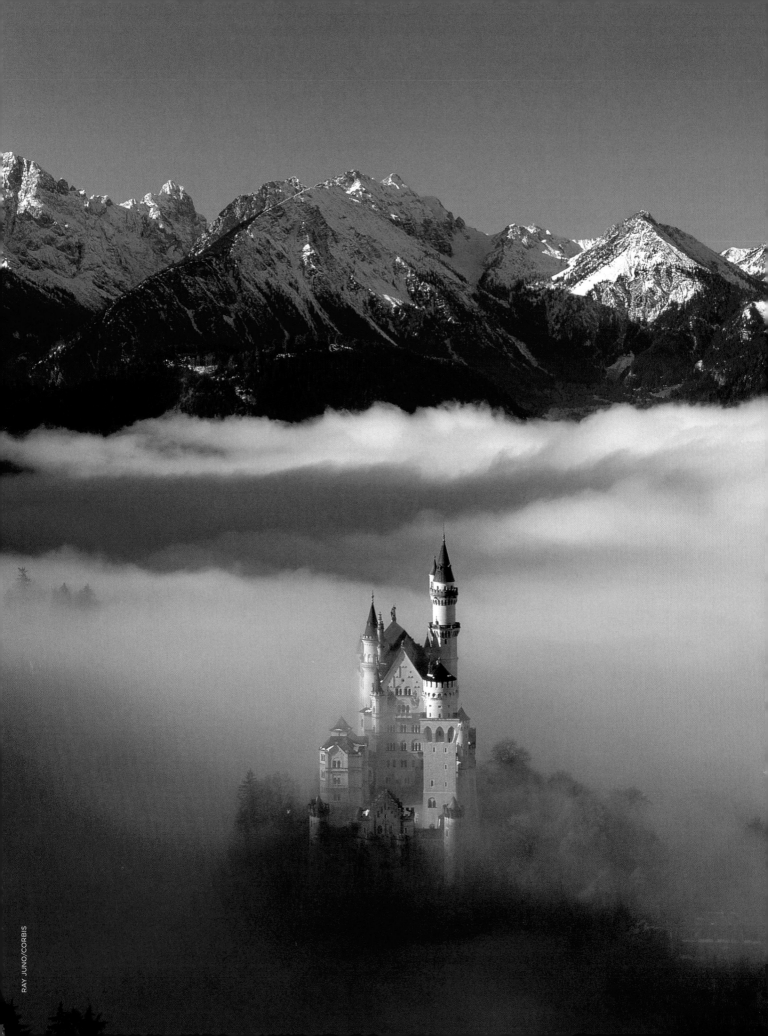

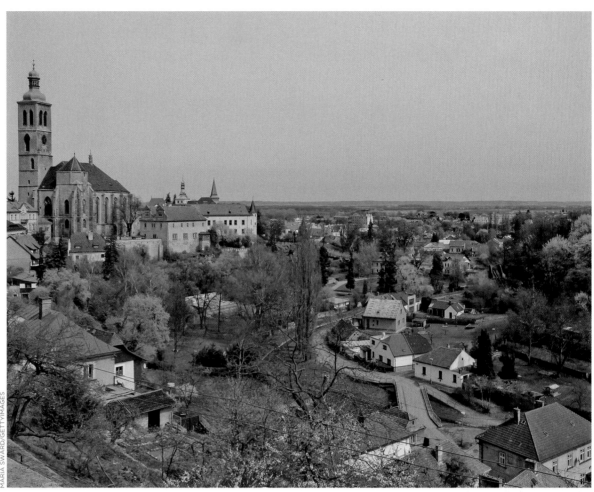

MARIA SWÄRD/GETTYIMAGES

KUTNÁ HORA
Czech Republic

Just an hour's drive from Prague sits Kutná Hora, once among the most powerful cities in Bohemia. Greatly enriched by its vast silver deposits, the city steadily rose in prominence from the 13th to the 16th century, when it drifted back into relative obscurity as its silver mines became tapped out. But it is still home to some wonderful examples of medieval architecture, as well as some more macabre curiosities, like the Sedlec Ossuary—or bone church, as it is more popularly known—a small chapel beneath the Cemetery Church of All Saints that contains the bones of some 40,000 to 70,000 people arranged in geometric shapes and decorative patterns in the corners and across the ceiling of the space. It seems that a quantity of dirt brought from the holy land and scattered over the outdoor cemetery in 1278 made it such a popular spot that the original residents—now in the chapel—had to be exhumed to make room for the vast number of newcomers.

NEUSCHWANSTEIN CASTLE
Germany

No American can gaze at images of Neuschwanstein Castle without thinking of the fanciful tales of Walt Disney and the many princesses and castles that figured so prominently in them. And indeed, this magical place, located above the village of Hohenschwangau in southwest Bavaria, was the inspiration for the Sleeping Beauty Castle in the original Disneyland in California. The castle is not old; it was built in the 19th century by King Ludwig II, who wanted to create a refuge far from Munich that would embody what he viewed as the ideal of medieval life. Lacking a historical pedigree, the castle is still viewed by many as the world's most beautiful.

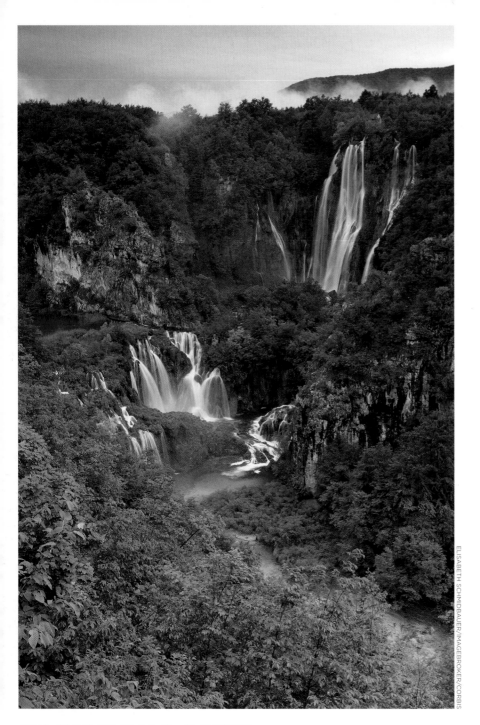

PLITVICE LAKES
Croatia

An array of interconnected lakes—16 of them, in varying sizes and shapes—
cascade their way through the enchanting terrain of Plitvice Lakes National
Park, producing a collection of waterfalls along the way, including the so-
called Large Waterfall shown here, which drops 256 feet from the end of the
last of the lower lakes in the park. With well-tended trails, wooden paths that
allow visitors stunning views from vantage points between many of the lakes,
and an astonishing collection of flora and fauna—you might see a brown bear,
a lynx or a golden eagle—Plitvice Lakes Park is a hiker's delight.

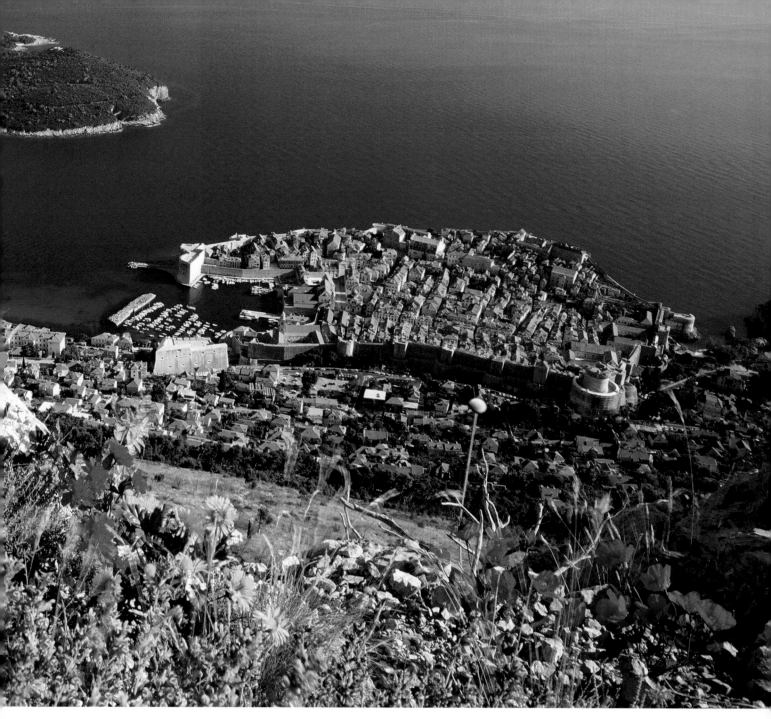

THE DALMATIAN COAST
Croatia

With the sun reflecting off the azure waters of the Adriatic and the wildflowers blooming in profusion, it is easy to forget the trauma suffered by magnificent, beautiful Dubrovnik and its ancient walled Old Town during the Serbian attacks in the 1990s. And indeed, perhaps from the perspective of history, such troubles will be seen as a mere blip on the Dalmatian radar screen. Visit this gorgeous city and reach your own conclusions as you enjoy the art galleries, the ancient architecture, the fabled food and drink and, of course, the sea, the eternal sea, ever in your eyes.

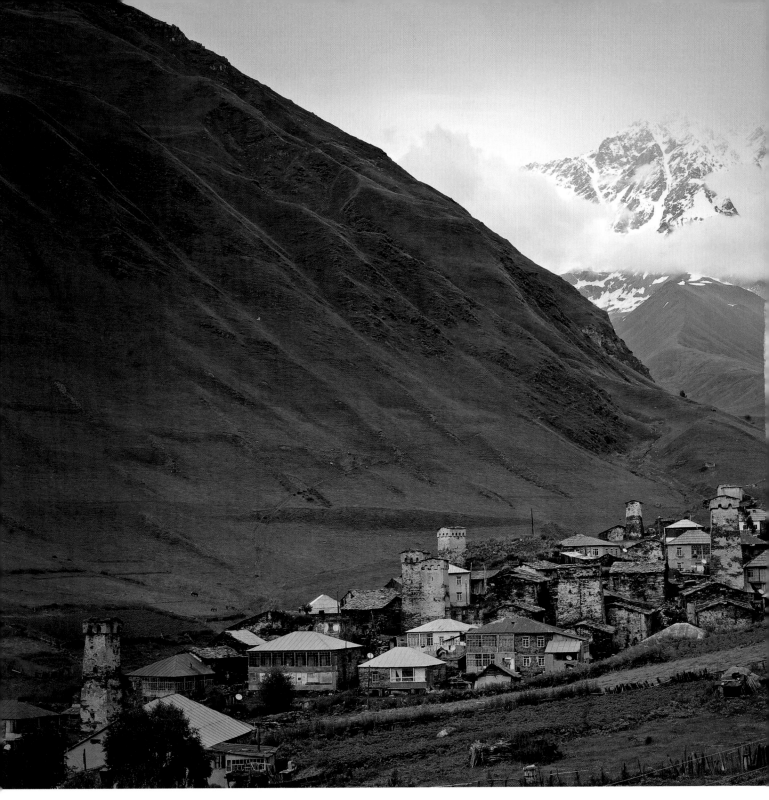

CAUCASUS MOUNTAINS
Russia and Georgia

For a trip to parts largely unknown to Westerners, one would be hard pressed to beat a visit to the vast Caucasus mountain range, which straddles the border between southern Russia and northern Georgia and runs from the Black to the Caspian Sea. With climes as diverse as the resort-like coastal region of Sochi, on the Black Sea in southwestern Russia, to remote—really remote—villages perched high in the hills, the mountains truly offer something for everyone. The village of Ushguli (population 200), shown here, boasts a line of medieval towers from the 10th or 11th century A.D. and at some 7,200 feet above sea level is believed to be the highest populated place in Europe.

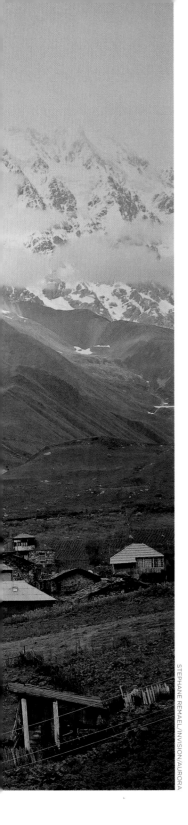

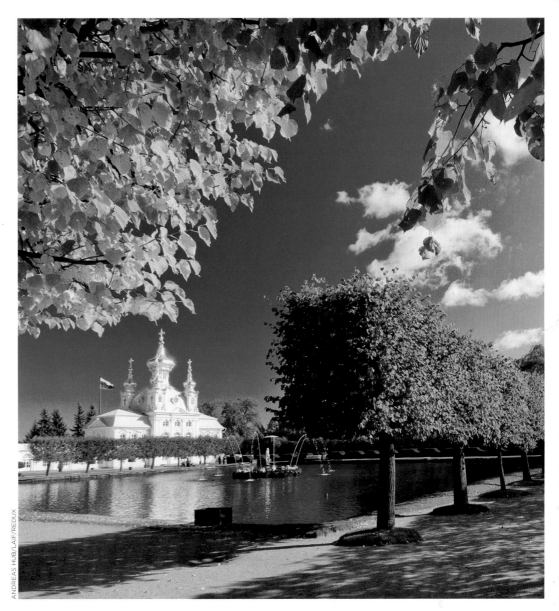

PETERHOF PALACE AND GARDENS
St. Petersburg, Russia

Referring to it as the "Russian Versailles" may be a bit of an overstatement, but Peterhof Palace and Gardens in St. Petersburg are magnificent nonetheless and well worth a visit. Designed in the early 18th century by Peter the Great as his summer residence, the complex includes the Grand Palace (along with a stunning man-made "cascade of golden fountains" in front of it), several additional smaller palaces on the grounds, meticulously maintained upper and lower gardens and, flanking the Grand Palace, a pair of ornately bedecked chapels. The East Chapel, shown here, is noted for its five gilded cupolas and was the traditional location for the baptism of Russian royalty. Severely damaged during World War II, the palace has been fully restored to its former grandeur.

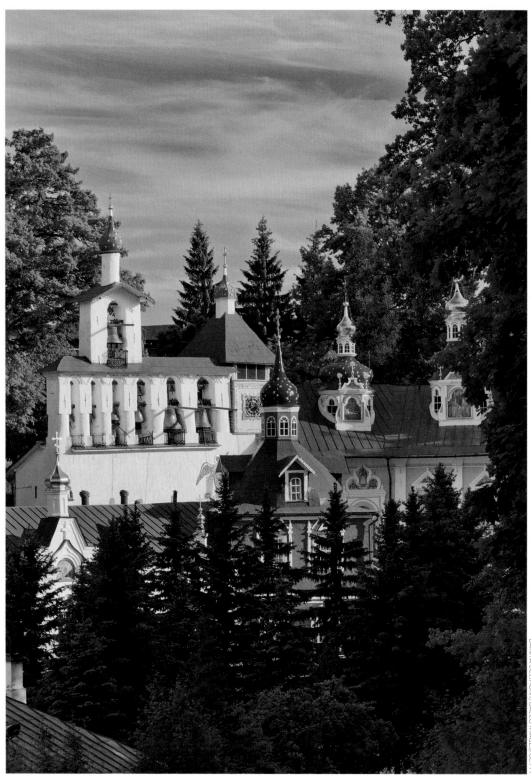

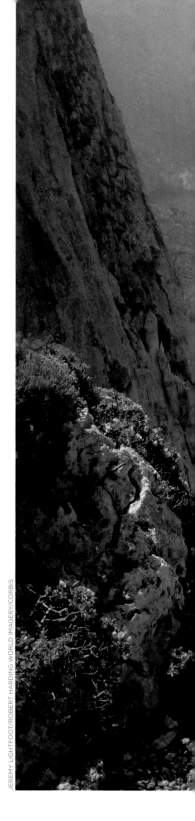

PECHORY, *Russia*

The tiny village of Pechory, on the extreme western border of Russia, sprung up around its stunning monastery, which is one of the oldest continuously operating religious communities in the world. Celebrating 540 years of existence in 2013, the monastery rose in importance as the first line of Russian defense on the western border in the 16th and 17th centuries, then fell into relative insignificance in later years and barely survived through the days of Soviet communism. Today, visitors are welcome to tour the fully restored, brilliantly colored buildings of the flourishing monastery, where some 90 monks continue to practice their ancient ascetic ways.

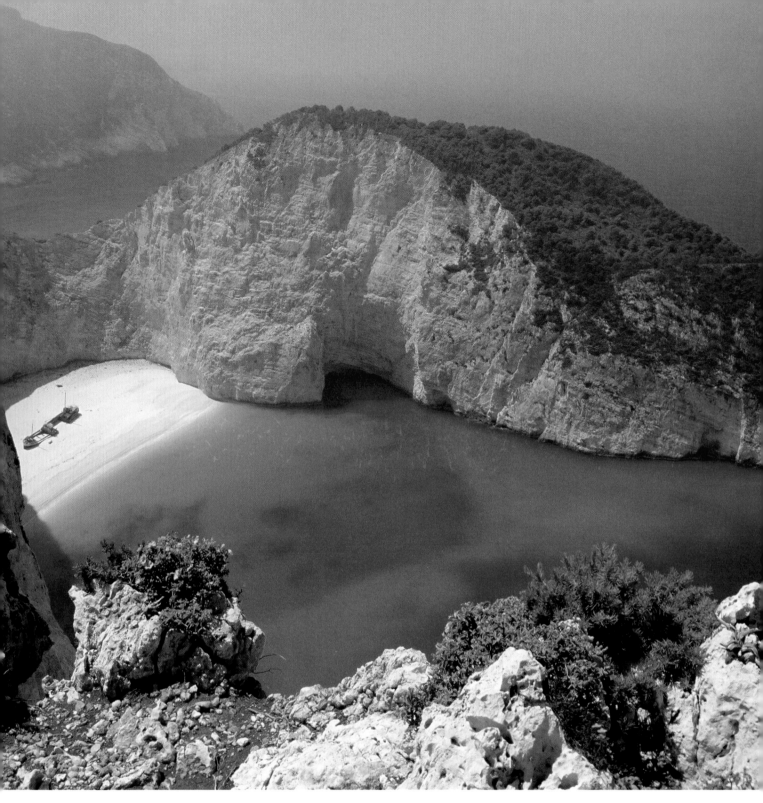

ZAKYNTHOS, *Greece*

If you've always dreamed of a sun-kissed vacation on one of the Greek isles, your imagination could not have conjured up a more perfect expression of that wish than the real-life island of Zakynthos, the third largest of the Ionian Islands. Blazingly bright turquoise waters offer sharp contrast to the deep greens of the surrounding hills; lazy sea turtles beckon you to explore the welcoming warmth, the underground caves and the other natural wonders beneath the sea's surface. Hike the mountains, savor the pleasing curves of the traditional white stone dwellings, bask in bliss on Navagio Beach, accessible only by boat—this is indeed the stuff of dreams.

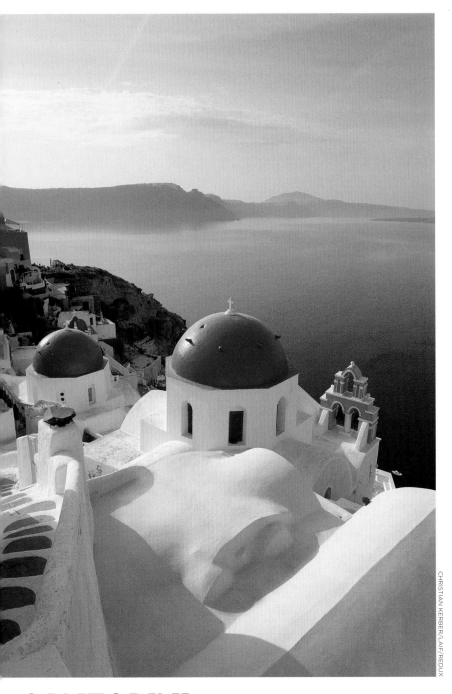

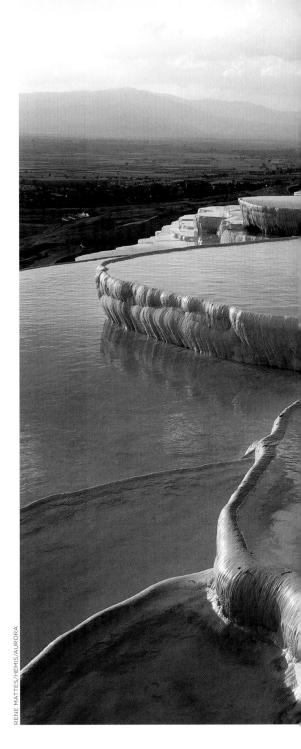

CHRISTIAN KERBER/LAIF/REDUX

RENE MATTES/HEMIS/AURORA

SANTORINI
Greece

Its elegant architecture and full-service airport make Santorini one of the most popular of the Aegean Islands, but its real claim to fame is the stunning views of the water-filled crater (caldera) formed approximately 3,600 years ago from a massive volcanic eruption. What remains, surrounding the caldera, is a circular archipelago, largely composed of steep 1,000-foot cliffs that plunge to the lagoon below.

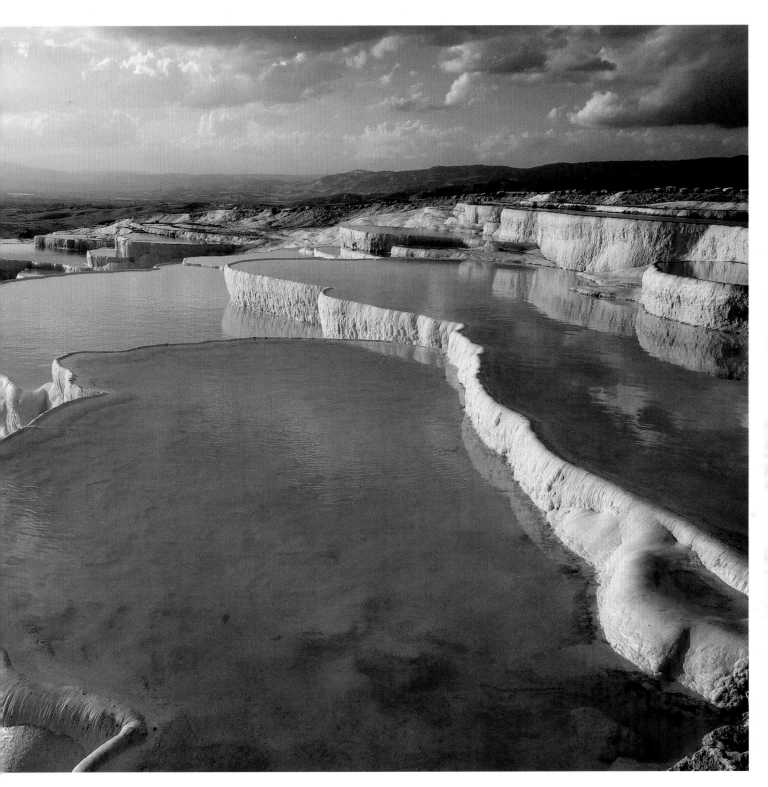

PAMUKKALE
Turkey

Among the world's most astonishing natural formations, the terraces of Pamukkale, in southwestern Turkey, are composed of travertine, a sedimentary rock deposited by water from the hot springs that bubble to the surface from underground volcanic activity. Pilgrims have trekked to the site for thousands of years to bathe in the warm, restorative waters that fill the terraces, but modern-day visitors are required to remove all footwear so as to protect the site. If you visit, be sure not to miss the ancient 15,000-seat Roman amphitheater of Hierapolis, just above the terraces.

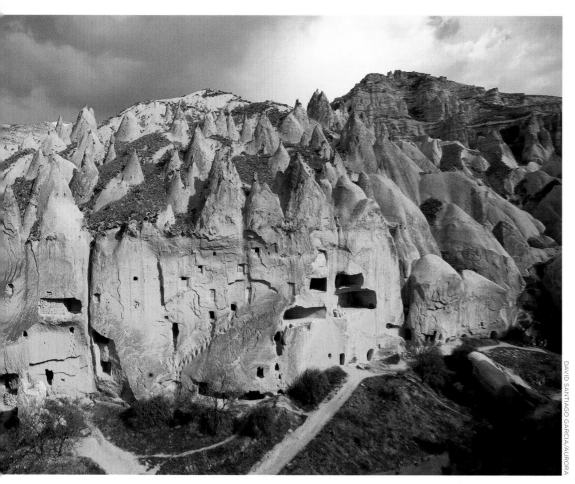

CAPPADOCIA
Turkey

To visit Cappadocia is to enter one of the world's most unusual landscapes, a result of persistent winds and natural erosion, sweeping across the flat lava-encrusted plain between two formerly active volcanos. Over the millennia, people have built intricate networks of homes in the rock, some above ground, like these in the Zelve Open-Air Museum (once a thriving community, now a tourist attraction), and others in caves underground. The conical rocks on the surface, known locally as "fairy chimneys," are typical of the region. Many of the communities were once inhabited by early Christians hiding from persecution.

SÜMELA MONASTERY
Turkey

Legend has it that the exquisite icon of the Virgin Mary that once formed the centerpiece of this breathtaking cliff-side monastery in Turkey was created by St. Luke and carried by an angel to a remote mountain cave. There it remained hidden until A.D. 386, when it was found by two Athenian priests named Barnabas and Sophronios, who decided to create a church to honor it on the spot. Now a museum welcoming visitors from around the globe, the monastery no longer houses the icon, which was moved to another location for safekeeping in 1930, but the brilliant and elaborate frescoes, the stunning stone architecture and the amazing views of the verdant mountains nearby make this a must-see destination for any Turkish trip.

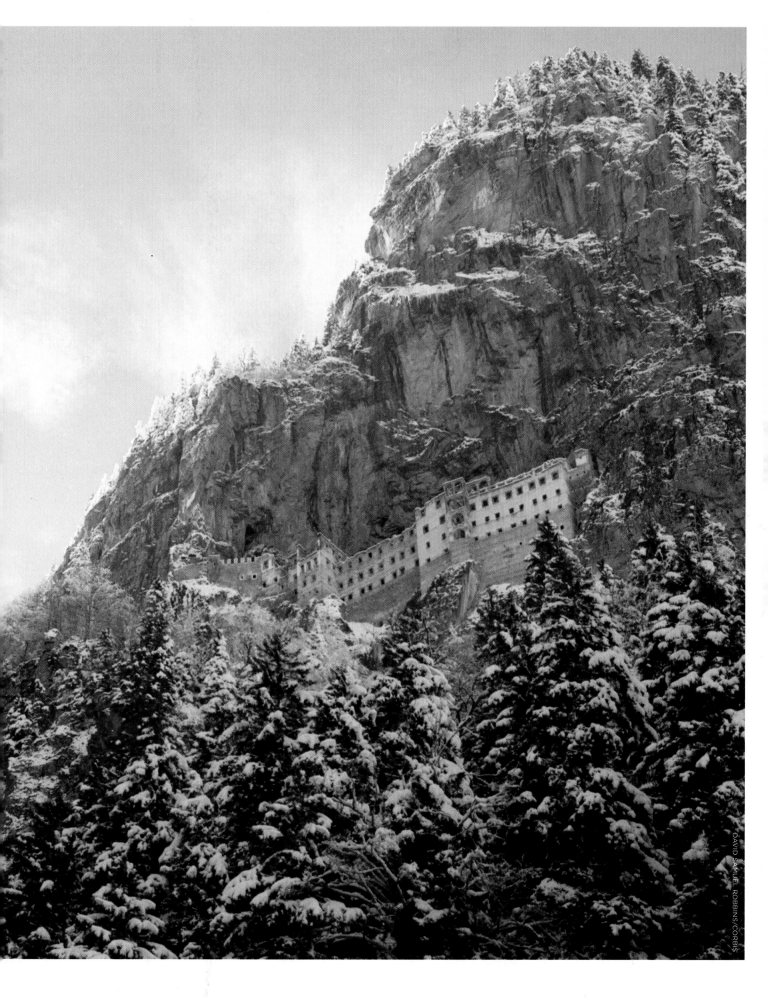

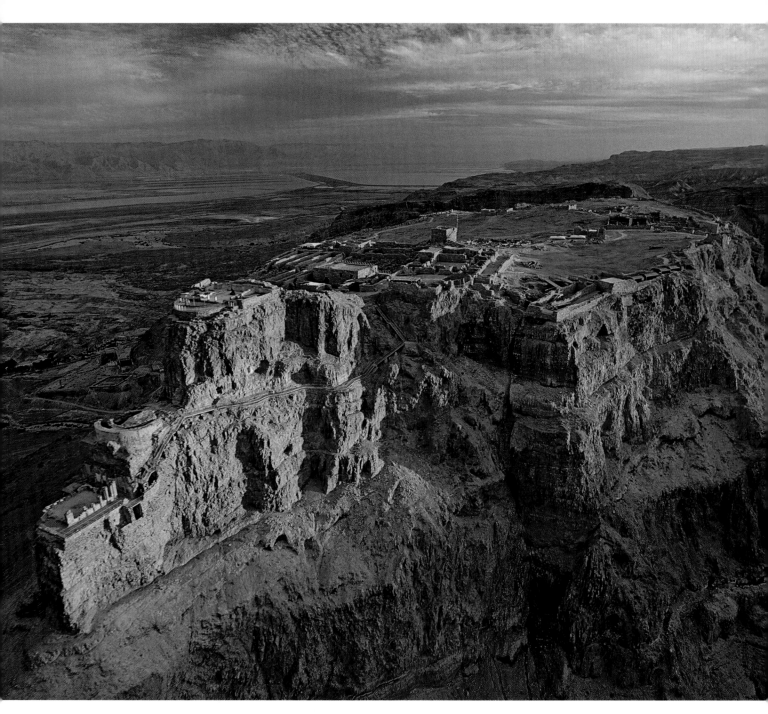

MASADA, *Israel*

Atop a plateau overlooking the Dead Sea in southeastern Israel stands the rugged fortress of Masada, a powerful symbol of Jewish resistance to Roman rule and an enduring reminder of the heroic band of 1,000 Jewish men, women and children who held off the vastly larger forces of the Roman Empire before choosing to commit suicide rather than submit to the yoke of Roman servitude. Built between 37 and 31 B.C. by Herod, the hated Roman-sponsored governor of Judea, the fortress was fully stocked with provisions and water (through a highly sophisticated system of cisterns) when it was taken over by Jewish rebels in A.D. 66; the fortress remained the rebels' home base until the Romans mounted their deadly siege in A.D. 73 or 74. Visitors today can reach the plateau via cable car, or by hiking up the ancient and narrow "snake path" that wends its way up the eastern slope of the plateau, or more easily via the ramp the Romans built for the assault on the western side. However you reach the fortress, and while you are enjoying the majestic views, take a moment to honor the sacrifice of the ancient heroes who once trod this hallowed ground.

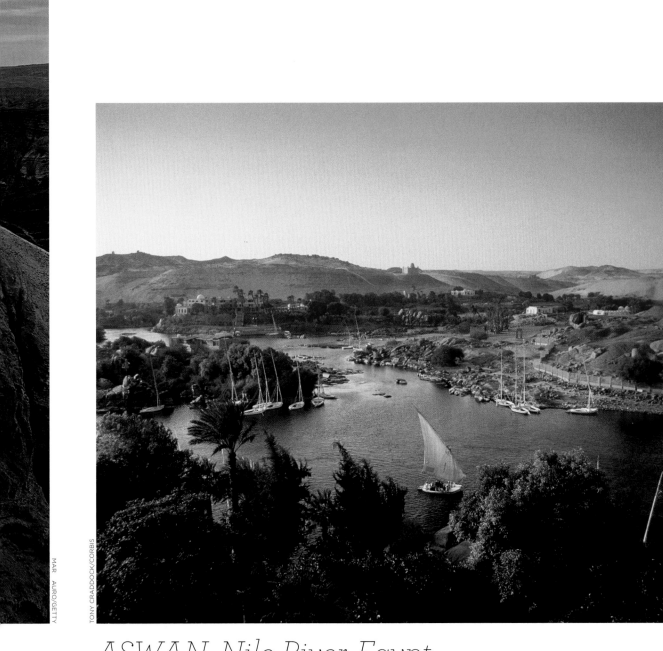

MAR AURO/GETTY

TONY CRADDOCK/CORBIS

ASWAN, *Nile River, Egypt*

The Egyptians called it "Iteru" or, very simply, "great river." One of humanity's earliest and greatest civilizations took shape under its influence. Explorers died navigating it; nations clashed in claiming it; worshipers bathed in it seeking health and solace. There is surely no river in the world more steeped in legend than the mighty Nile. Today, it remains a fundamental influence for millions of people living on or near the banks of its serpentine 4,132-mile length, including those in Aswan, Egypt's hottest and driest of cities, located in southern Egypt on the eastern bank of the Nile, just above the Aswan Dam. Here, the pace is slower and more relaxed than in frenzied Cairo, and the city is small enough to explore easily on foot. Sunsets like this one over the Nile are spectacular, and the wonders of Luxor are only 80 miles away.

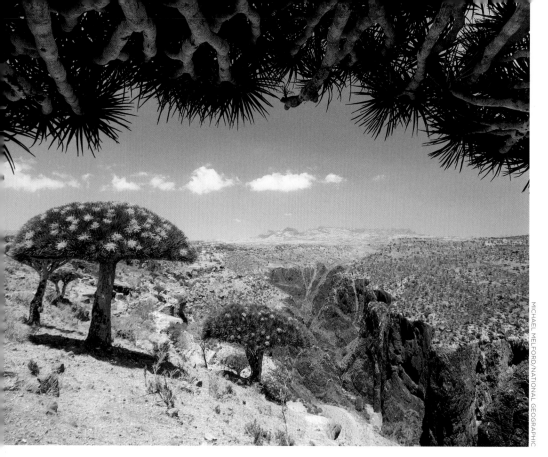

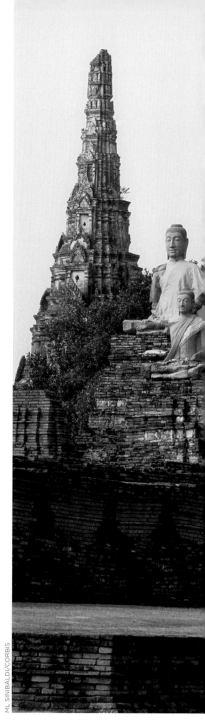

SOCOTRA ISLAND
Yemen

Some 220 miles off the coast of Yemen, in the Arabian
Sea, sits the island of Socotra, one of the most biodiverse
locations in the world, with an array of plants found nowhere
else, including groves of dragon's blood trees like these,
tapped in ancient times for their dark red sap, which was
said to possess healing powers. For centuries, the native
peoples pursued their lives undisturbed on the hot, windswept
island, fishing, herding their goats, harvesting their dates and
communicating in a language known only to themselves. Now,
with tourism on the rise and efforts by the Yemeni government
to modernize the island, much of this native culture is under
threat. Go see it while you can, but tread lightly.

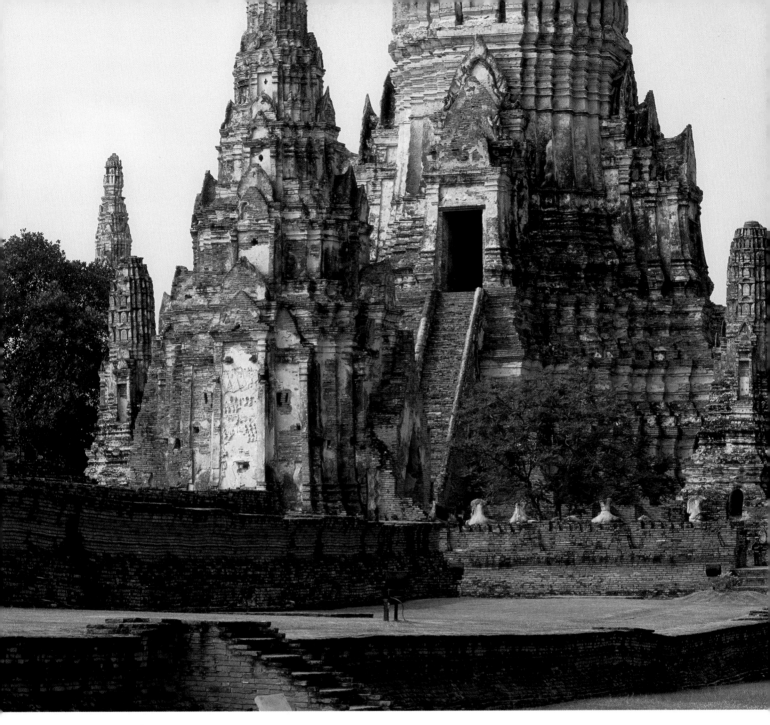

AYUTTHAYA
Thailand

Should you need any further reminder of the transitory nature of human existence, consider a trip just 50 miles north of Bangkok to the city of Ayutthaya. This is not a name known to Westerners in general, and even in Asia the city is little known. And yet, in 1700, Ayutthaya (founded in the 14th century) was the world's largest city, with a population of one million people, and ranked among the world's most significant and prosperous trading centers. Ideally located at the confluence of three rivers, it was fully accustomed to welcoming merchants from the Arab world, China, India, Japan, Portugal, the Netherlands and France. Visitors returned to their homelands with tales of the city's opulence and beauty. Tragically, the Burmese invaded in 1767 and burned the city to the ground, bringing its days of prominence to a crashing halt. Yet even today a sense of the city's former grandeur can be glimpsed in the many stone structures—palaces and temples for the most part—that survived the fires, like the ruins of Wat Chai Wattanaram Temple, shown here. Their glory was dimmed by the destruction, but they are well worth a visit nonetheless.

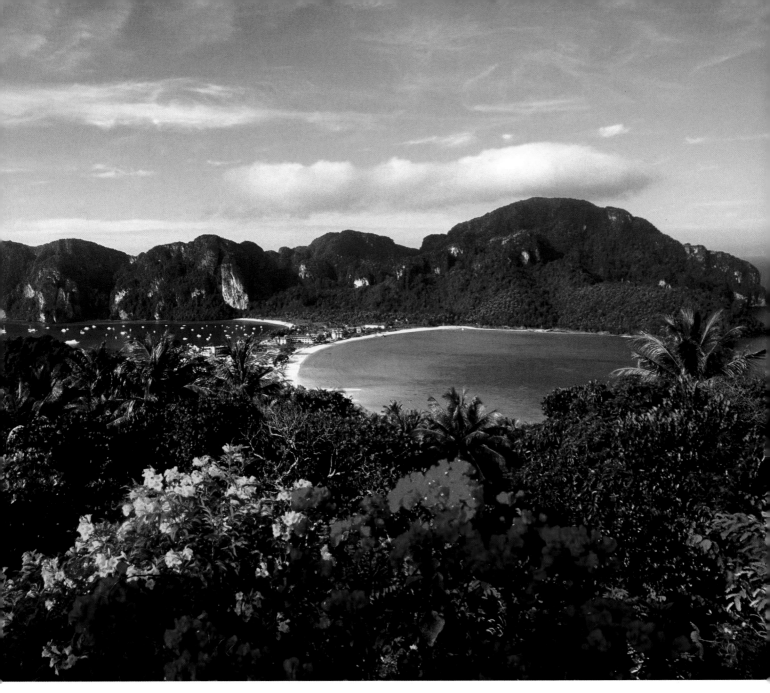

KO PHI PHI
Thailand

Splashes of intense color from an array of topical flora dot the
landscape on Ko Phi Phi Don, the largest of the six islands that make
up the archipelago of Ko Phi Phi off the coast of Phuket in southern
Thailand. Once virtually unknown to western tourists, the islands
are beginning to garner a bit of a buzz, and high-end resorts and
hotels have sprung up to cater to the rise in interest generated by
the gorgeous beaches, tropical temperatures, fabulous coral reefs
and wonderful, spicy food. The local culture reflects a happy and
peaceful amalgam of Buddhists, Thai-Chinese, Muslims and even the
aboriginal Malay people known as the Urak Lawoi.

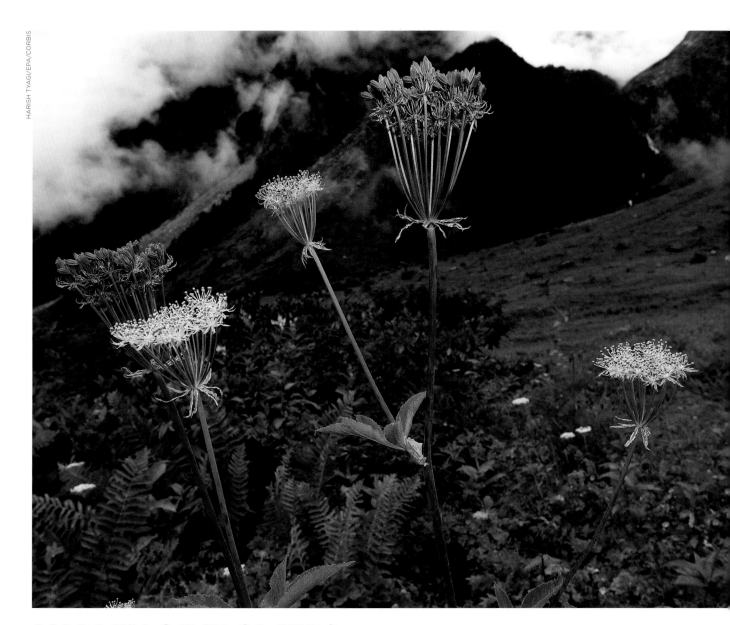

VALLEY OF FLOWERS
India

A visit to India's Valley of Flowers National Park, located high in the western Himalayas, is not for the faint of heart. Getting there requires a significant trek, with few amenities on the way or upon your arrival. But what this relative inaccessibility has maintained is one of the world's most unspoiled, beautiful natural landscapes, a highland paradise, perched between the severe mountain regions to the north and east—the 25,646-foot peak of Nanda Devi, the second highest in India, is ever in view—and the plains of India below and to the west. Here in this rarefied locale, the Valley of Flowers more than fulfills its name, blooming with an astonishing range of wildflowers, many of them unique to the region. Wildlife abounds as well, including many of the world's most endangered, exotic species such as the Asiatic black bear, snow leopard, brown bear and blue sheep. Westerners who stumbled into the valley in times past were entranced by the place; locals have always viewed it as magical, one ancient legend even depicting it as the home of the fairies. Accept the challenge and make a visit—you'll be a believer too.

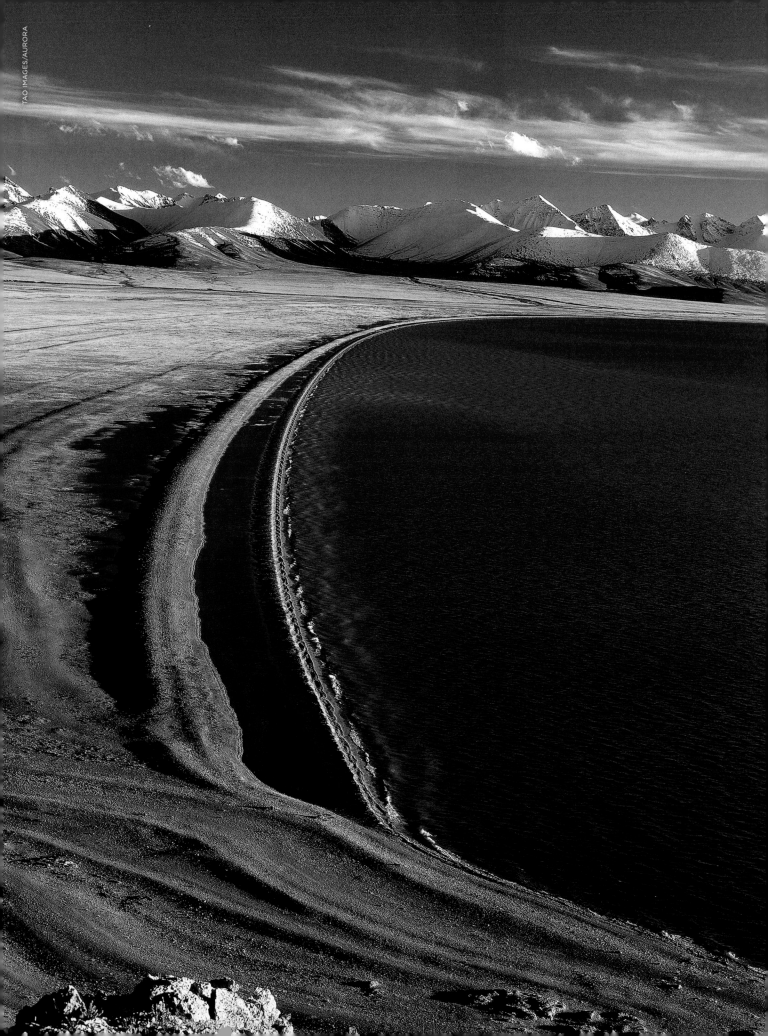

NAMTSO
China (Tibet)

Every year in late summer, just before the bitter cold of the fall and winter descends on this mountainous region of Tibet, a motley collection of travelers—nomads, city dwellers, monks and pilgrims—trek to the shores of beautiful Namtso (elevation 15,479 feet) to eat, drink, dance and enjoy the spectacle of the wild, no-holds barred horse races held on a flat piece of grassland beside the lake. With no lanes and few rules, the races often produce disputed results, but the controversy never puts a damper on the celebration. Even amidst the commotion of the races, visitors take care to hang prayer flags like these, expressing their hopes and dreams to be carried to the heavens by the great Wind Horse, a pre-Buddhist Tibetan symbol of speed (wind) and strength (horse).

PANGONG TSO
Himalayas, India and China

One can only imagine the wonder felt by the first explorers who trekked between the snow-capped peaks of the Himalayas and caught their first glimpse of the deep, deep blue of Pangong Tso, which sits on the border of India and China at an elevation of more than 14,000 feet. Gigantic sand hills surround parts of the lake, the views of the mountains are stunning and the walks in and out of the location are among the most interesting in Asia. One final asset: while tourists do make their way to the lake, they are small in number.

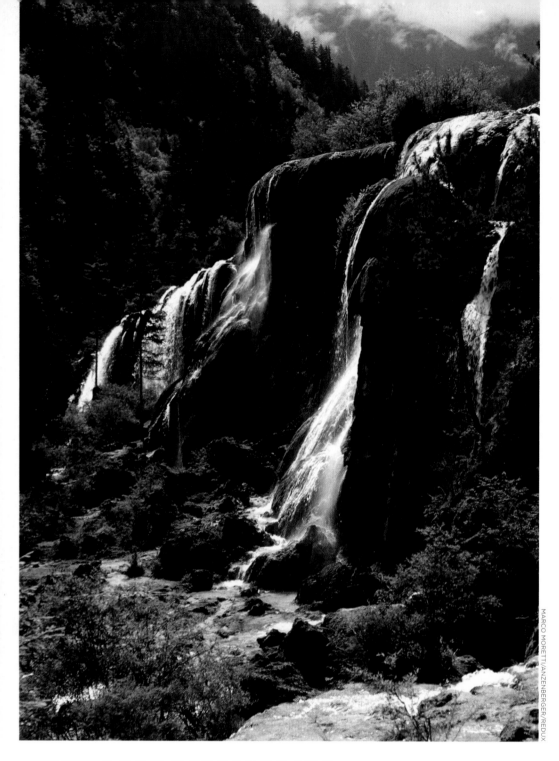

MARCO MORETTI/ANZENBERGER/REDUX

RENE MATTES/HEMIS/CORBIS

JIUZHAIGOU VALLEY
China

Pearl Shoal Waterfall is just one of the stunning natural wonders awaiting visitors to Jiuzhaigou Valley in southern China's Sichuan Province. Evergreen hills, snow-capped mountains, lakes that shimmer in an array of blues and greens rarely seen in the natural world, local villagers who practice their own brand of Tibetan Buddhism and offer thirsty travelers yak butter tea—this may be as close as any of us will get to Shangri-La.

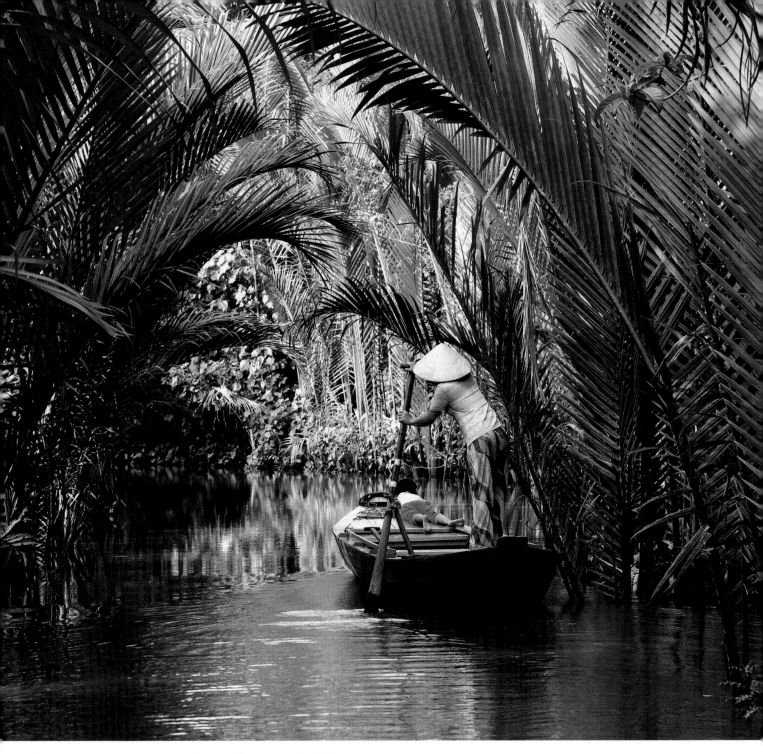

MEKONG DELTA
Vietnam

For Americans of a certain age, the Mekong Delta carries a tortured association as the place where U.S. soldiers died in droves, attempting to conduct combat across swampy terrain with no paths, no targets and few glimpses of the enemy—all in a conflict many Americans did not support. But Vietnam is a different place now, and within its borders lies some of the most beautiful terrain in the world, including the Mekong Delta, the southernmost region of Vietnam, where the mighty life-giving Mekong River floods the area during the rainy season, nourishing crops and providing a bountiful catch for local fishermen. Vietnam now welcomes Americans to these flat, endless tropical wetlands on luxurious tours of its canals, its floating markets and its positively stunning array of flora.

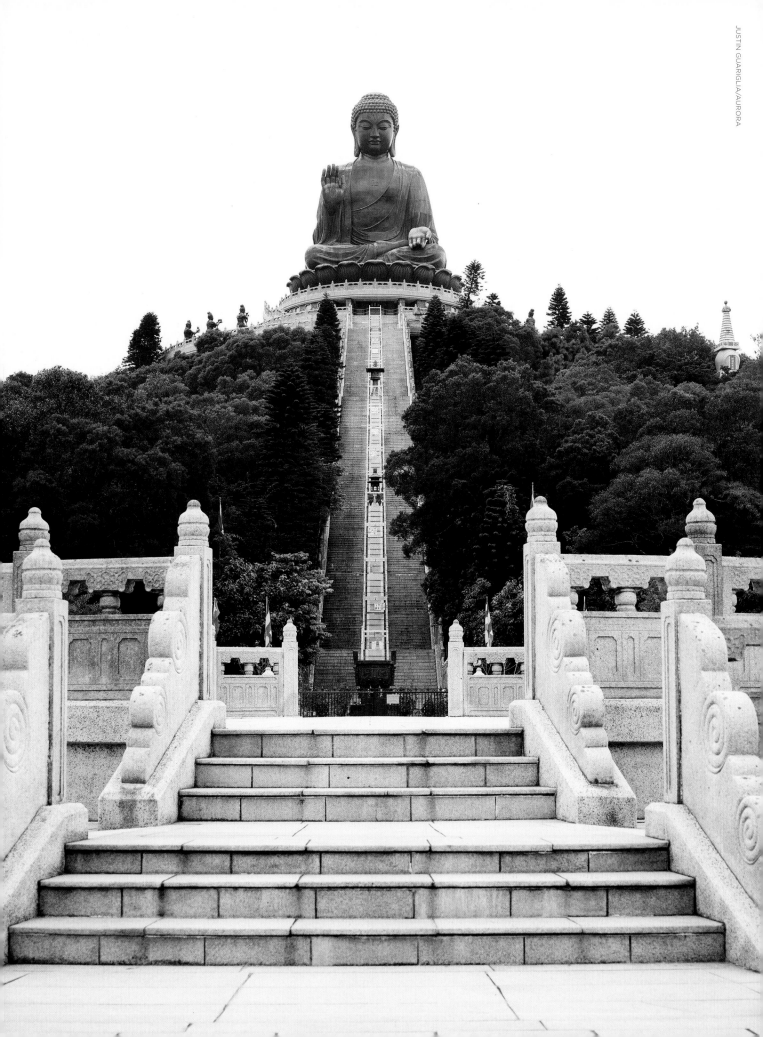

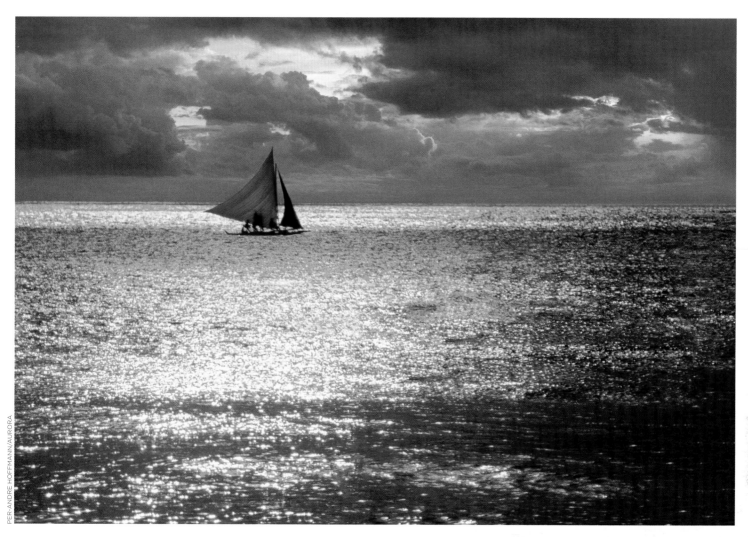

BORACAY ISLAND
Philippines

A painless one-hour flight is all it takes to transport you from the hustle, bustle and congestion of Manila to Boracay Island, just off the Philippines' much larger island of Panay and home to a collection of gorgeous white-sand beaches and unforgettable sunsets to rival anything you'll find in the Caribbean or the South Pacific. Of course, there is fabulous snorkeling, sailing and windsurfing, but with an array of beach-side resorts and high-end hotels—as well as an appealing collection of eating and drinking establishments in easy strolling distance—many visitors may find it most appealing to move as little as possible.

LANTAU ISLAND
Hong Kong

No, this giant so-called Tian Tan Buddha is not an ancient artifact. In fact, the 112-foot statue was constructed—the head is composed of bronze and gold, the body of bronze—quite recently, in 1993, at a cost of nearly $8 million. So it goes in highly commercial Hong Kong and on Lantau Island, Hong Kong's largest outlying island, where tourism is courted in every imaginable corner, from its lovely beaches to its western-style shopping malls to its Disneyland. Nonetheless, the giant Buddha attracts devout pilgrims from around the world as well as tourists attracted to the endless views from its base.

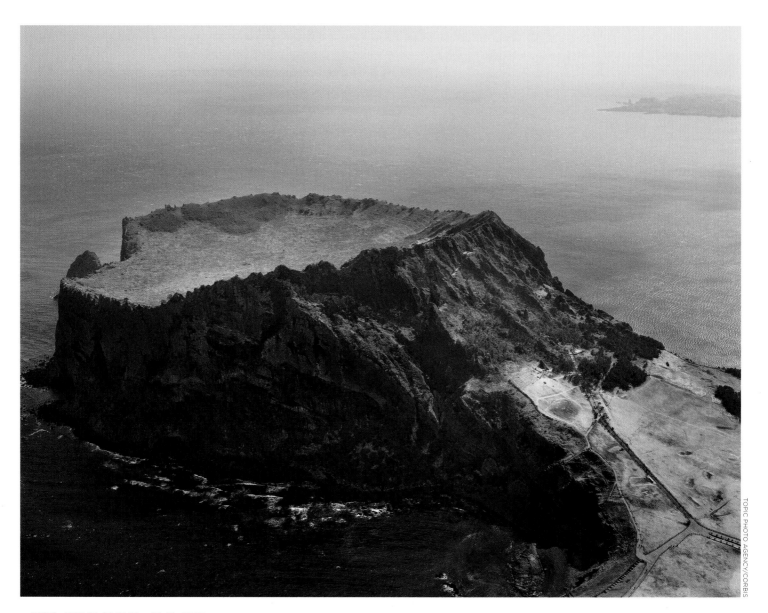

JEJU ISLAND
South Korea

Seongsan Ilchulbong, or Sunrise Peak, is a popular tourist destination on tiny Jeju Island, off the southern coast of South Korea. Formed some 5,000 years ago, this so-called "tuff cone" is what's left of a volcano that erupted from beneath the ocean, then collapsed, leaving this rugged 600-foot rock edifice, like the prow of some ancient stone ship, pointing out to sea and offering stunning views of the surrounding seascape. The island, with its warm climate, wonderful beaches and fabulous hiking, has long been a favorite destination for Korean honeymooners, so if you are planning a visit, be sure to book your rooms well in advance.

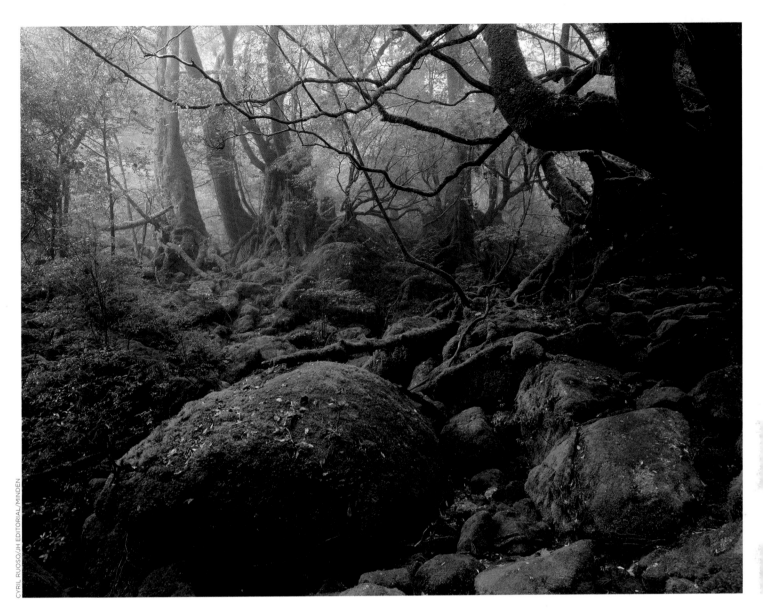

YAKUSHIMA ISLAND
Japan

Any American entranced by the magical worlds created by Japanese animé master Hayao Miyazaki will feel transported into his fertile imagination by a visit to Yakushima Island and its incomparably beautiful ancient Yakusugi rainforest, off the coast of southwestern Japan. In fact Yakushima was indeed the inspiration for *Princess Mononoke,* one of Miyazaki's most brilliant films and a clarion call for the preservation of this precious and irreplaceable natural world. Stroll down one of the island's many well-maintained trails, gaze at the water cascading everywhere, pause on one of the many charming narrow bridges or marvel at the geometry of moss-covered rocks like these—is it so hard to imagine wood sprites and nymphs peeking at you from behind the trees?

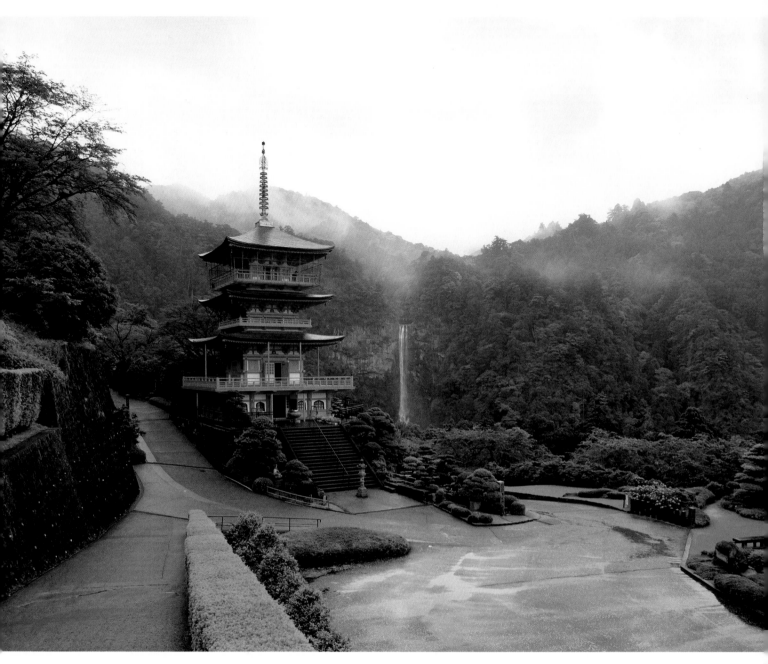

KII MOUNTAINS
Japan

The lovely Kii Mountains, which jut into the Pacific Ocean off the southern coast of
Japan—and particularly the Kumano region closest to the sea in the southeastern
section of the mountains—constitute sacred ground for Shinto pilgrims, who
for centuries have walked the carefully kept and sometimes arduous paths that
connect the three sacred shrines and two temples located within 25 miles of one
another in the densely wooded hills. Seiganto-ji Temple, shrouded in mist and
hard by beautiful Nachi Falls, remains one of the most prominent examples of the
syncretist tendency in Japan to blend the ancient Shinto forms of nature worship
with Buddhist philosophy. With the revered Kumano Nachi Taisha shrine nearby,
the area is suffused with a sense of mystical possibility; approach with reverence.

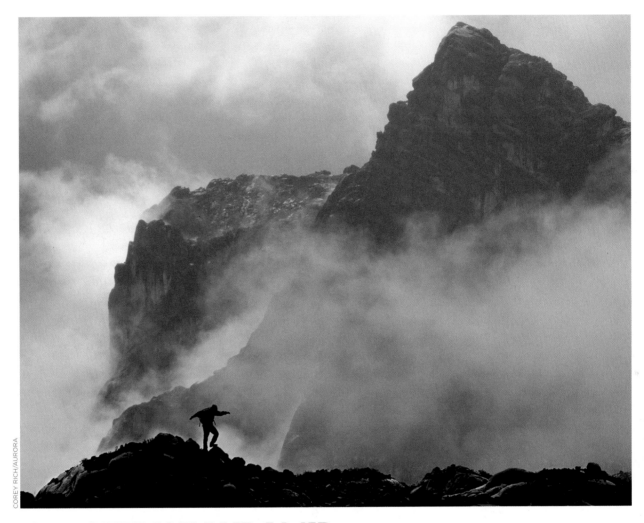

CARSTENSZ PYRAMID
West Papua, Indonesia

In 1623, when Dutch explorer Jan Carstenszoon returned
to his homeland and reported seeing a snow-capped peak
surrounded by tropical jungle near the equator, he was
widely ridiculed, and it would be two centuries before his
sighting would be confirmed and the mountain's peak
named in his honor. Relatively diminutive when compared
to the peaks of 22,000-feet-plus in the Andes and Himalayas,
the mountain's elevation of 16,024 feet remains the highest
in Oceania, and the ascent to its peak is still considered one
of the most technically challenging in the world.

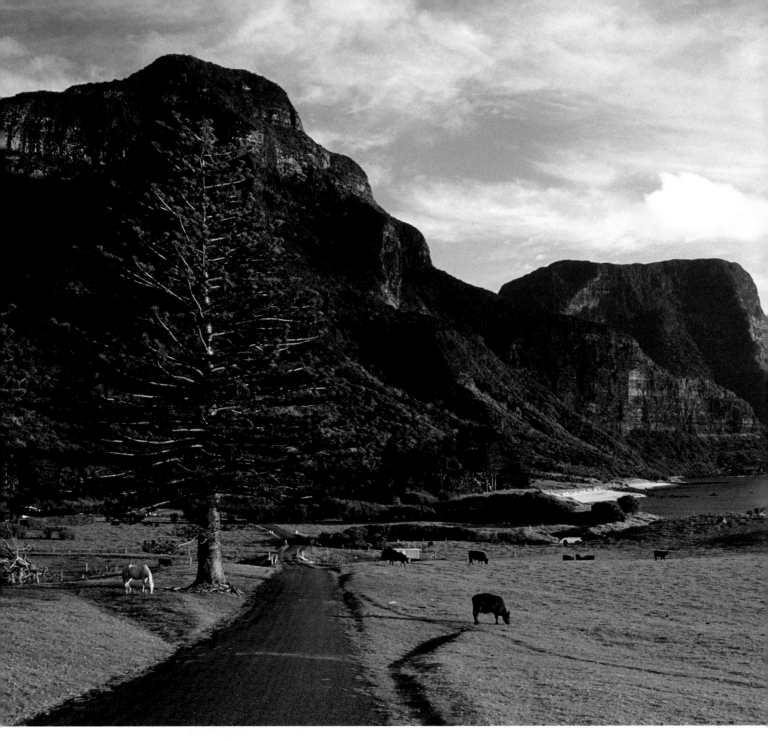

LORD HOWE ISLAND
Australia

Your cell phone won't work on Lord Howe Island, located in the Tasman Sea, 342 miles off the coast of eastern Australia. But isn't that the idea of a real vacation? This lovely crescent shaped island—it's actually the top of a now-defunct underwater volcano—is small (six miles long and just a mile across at its widest), sparsely populated (only 350 permanent residents), and the powers that be restrict the total number of visitors on the island at any one time to a very manageable 400 people. If you get to be among that lucky number, you will enjoy a place of exceptional natural beauty, with a lovely subtropical climate: Highs are in the upper 70s in summer (December–March) and the upper 60s in winter (June–September). Outdoor activities occupy pride of place on the island, including hiking, snorkeling and scuba diving—don't miss the world's southernmost coral reef off the coast—swimming, surfing and kayaking.

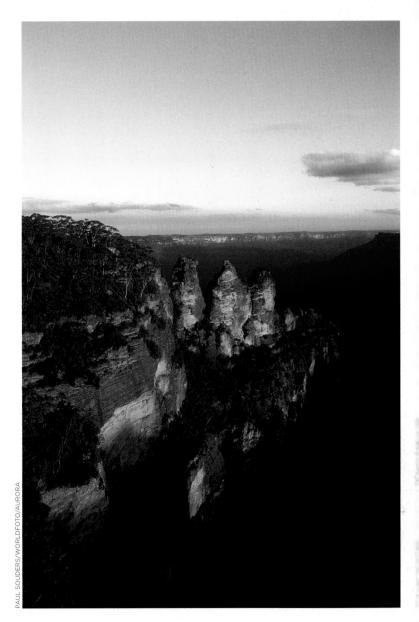

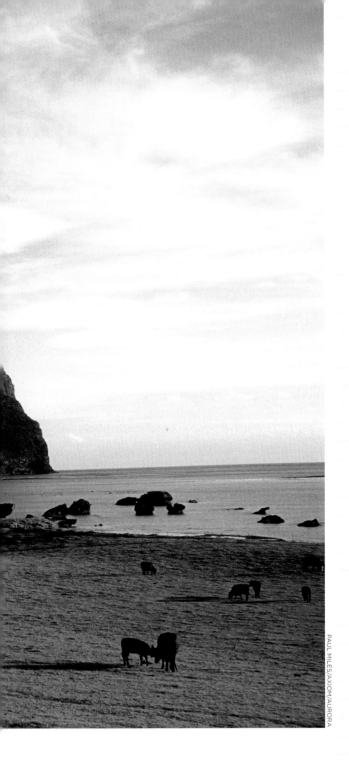

BLUE MOUNTAINS
Australia

Back on mainland Australia, to the west of Lord Howe Island, the picturesque Blue Mountains offer an array of pleasures for those making the journey Down Under. Once the home of the Gundungurra and Darug Aboriginal peoples, the mountains now boast many attractions, such as laid-back Katoomba, an old resort town just off the Great Western Highway between Sydney and Bathurst, with a popular skyway and railway that travel up and down some very steep terrain nearby, providing passengers with amusement park thrills as well as breathtaking vistas. Also in Katoomba is Echo Point, which features some of the most memorable views in the entire mountain range, including this one of the Three Sisters rock formation in the foreground and Jamison Valley stretching off into the distance behind it. The derivation of the Three Sisters' name is unclear, though one popular story claims that it comes from three star-crossed sisters turned to stone by a witch doctor who was killed before he had the chance to undo the spell.

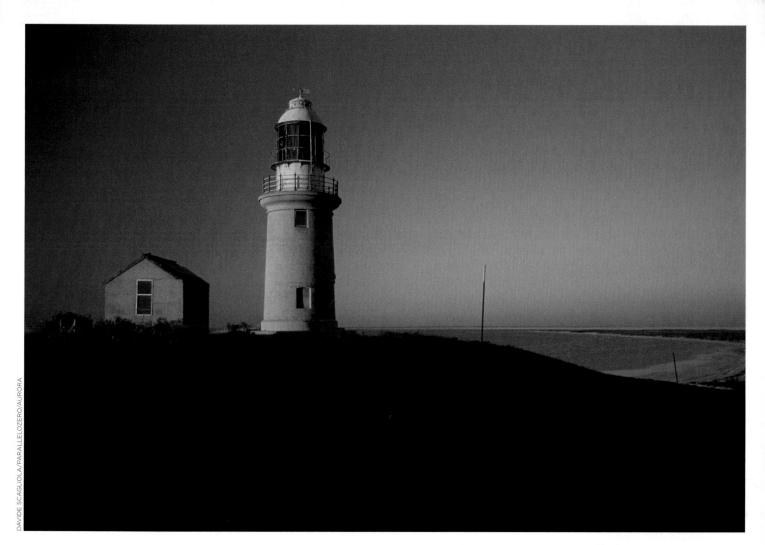

NINGALOO COAST
Australia

The elegant Vlamingh Head Lighthouse has stood on a promontory beside the Indian Ocean in western Australia since 1912, offering panoramic views of the Ningaloo Coast and its gigantic 162-mile coral reef, which begins almost the second you enter the water off its pristine white-sand beaches. To snorkel or sail in these seas is to encounter a truly astounding collection of marine life: dolphins, dugongs, manta rays, moray eels, loggerhead turtles, clownfish and a dazzling array of colorful tropical fish, as well as massive humpback whales. Not to be missed.

FREYCINET NATIONAL PARK
Tasmania

Rocky challenges like this abound in Freycinet National Park, a peninsula of rock and sand that juts into the Tasman Sea off the eastern coast of Tasmania. Take a trek across the landscape of pink granite; bask in the sun on the beach at Wineglass Bay, named by *Outside* magazine as one of the world's most beautiful; snorkel or scuba dive in the clear turquoise waters teeming with colorful marine life; or spend a couple of hours scanning the skies for the sea eagles soaring overhead or the gannets diving for fish. The choices are almost endless.

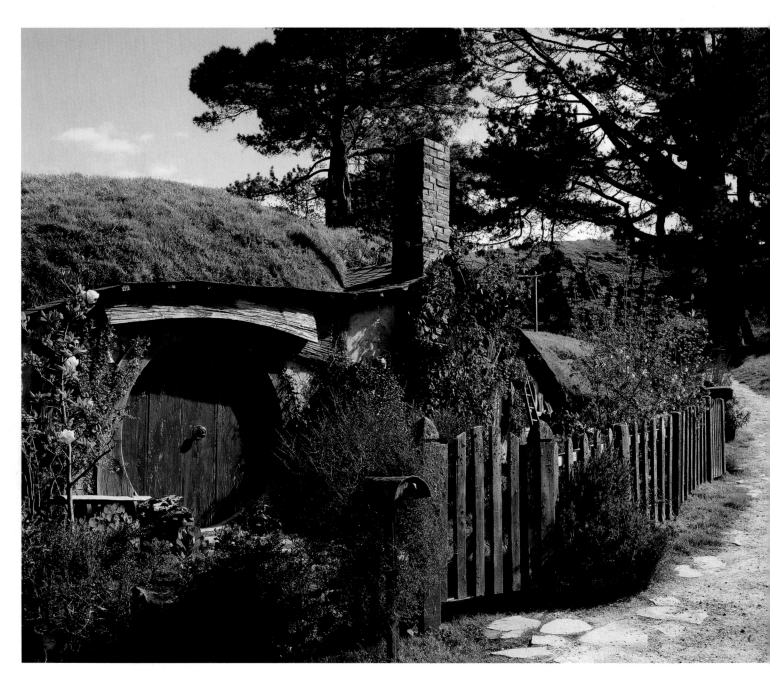

THE HOBBIT TRAIL
New Zealand

The enormous success of director Peter Jackson's film treatment of J.R.R. Tolkien's *The Lord of the Rings* trilogy has spawned an entire cottage industry devoted to taking die-hard *Rings* fans to the various sites in New Zealand used by Jackson for his movies. Hobbiton, the fictional hometown of the Hobbits, and most particularly of Bilbo Baggins, the title character in Jackson's latest film, *The Hobbit: An Unexpected Journey,* is the most popular destination by far. With a sprucing up related to its appearance in the new film, the 1,200-acre set, located near rural Matamata, two hours south of Auckland in northern New Zealand, has never been more charming or more true to Tolkien's original vision. There are no hokey American theme-park touches here, just a series of country lanes, a real-life valley and 44 little Hobbit homes like this one, each properly sized for an inhabitant of only three feet six inches, with a quaint round door and windowsills filled with unusual knickknacks, just as Tolkien described. A home to long for, indeed, just as Bilbo did when he undertook his momentous journey outside the shire.

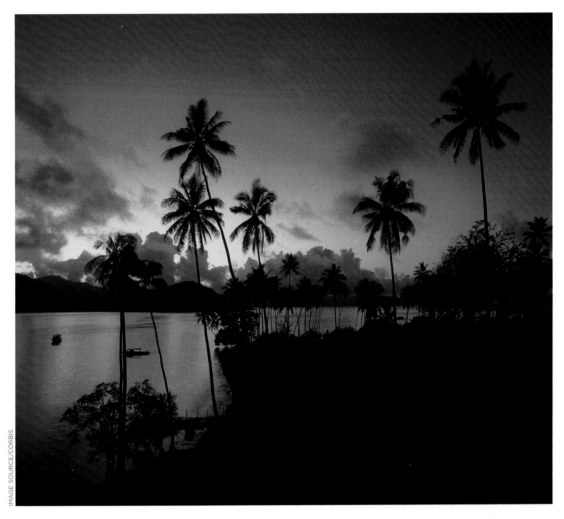

QAMEA AND
MATANGI ISLANDS, *Fiji*

Just over six miles long, the islet of Qamea and its
even smaller sister isle Matangi Island just to its north,
may express the archetypal tropical paradise we all carry in
our heads more fully than any other location on earth.
Comfortable sea breezes, palm trees swaying overhead,
warm tropical waters of the South Pacific—does it get any
better than this? Add a sunset saturated with color like
this one and a high-end resort catering to your every
whim, and maybe, just maybe, we have at last reached the
very ideal of paradise.

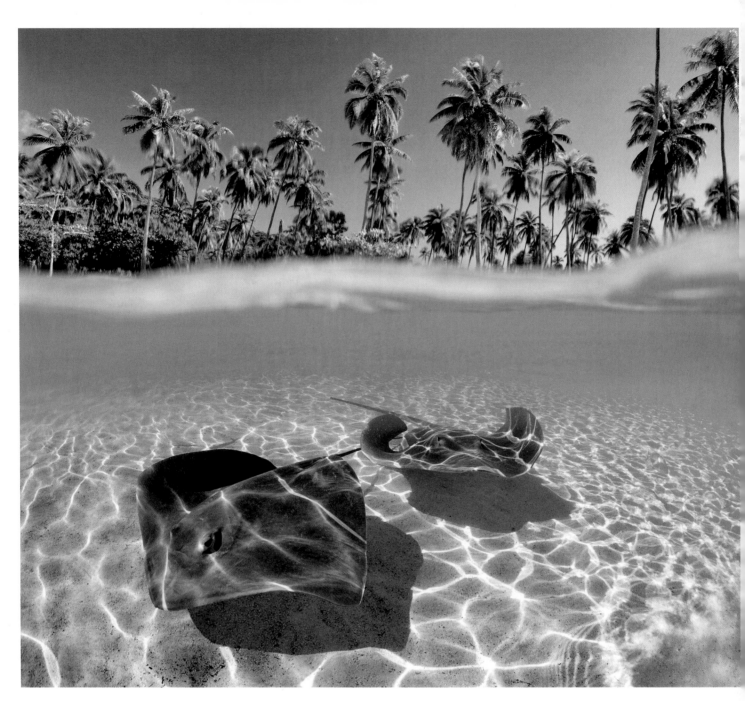

MOOREA
French Polynesia

Local lore has it that Moorea is the island that the residents of Tahiti, just 12 miles to the east, go to for *their* vacations. Less heavily touristed, less expensive—though still blessed with several well-appointed resorts—and more laid back, Moorea has all the assets associated with its middle-of-nowhere location in the South Pacific, a tad less than halfway between Australia and South America. Gorgeous, warm, translucent green waters, tropical temperatures, elegant beaches of both black and white sand and an eye-popping array of marine life like this pair of sting rays make this Polynesian getaway a destination for the ages.